Skira Architecture Library

New Italian Architecture

Italian Landscapes between
Architecture and Photography

edited by
Pippo Ciorra and Marco D'Annuntiis

Skira

Editor
Luca Molinari

Editing
Claudio Nasso

Layout
Paola Ranzini

First published in Italy
in 2000 by Skira Editore S.p.A.
Palazzo Casati Stampa
Via Torino 61
20123 Milano, Italy

Printed and bound in Italy.
First edition.

ISBN 88-8118-654-3

Distributed in North America
and Latin America by
Abbeville Publishing Group,
22 Cortlandt Street, New
York, NY 10007, USA.
Distributed elsewhere in the
World by Thames and Hudson
Ltd., 181a High Holborn,
London WC1W7QX,
United Kingdom.

Table of Contents

Kay Bea Jones

"New Architecture for Our Cities: Italian Lessons"

Italo Calvino forecasted six formal concerns for the next millennium while lecturing at Harvard over a decade ago. Published in Italian, they are *Lezioni Americane* (American Lessons). Since one often sees more, and more clearly, when away from home, I propose a reflection on our cultural affinities through emerging form in these Italian lessons.

On the occasion of the 1999 Association of Collegiate Schools of Architecture International Meeting in Rome, ten Italian architecture teams were selected to exhibit their new work, some built, some still in development, some as proposals or ideas. The exhibition "Nuova architettura per nuove città" opened on May 31 at the Galleria Comunale d'Arte Moderna e Contemporanea on Rome's Via Francesco Crispi following the keynote address by Pippo Ciorra, one of the architects whose work was included in the show.

The Rome gathering of nearly 300 architectural pedagogues and scholars from around the world, hosted by a North American association, was co-chaired by Trina Deines and myself. We sought to engage contemporary Italian approaches to formal and social urban problems as central to the discussion among the architects in attendance. The conference theme, "La Città Nuova" (The New City), presented an inherent conflict since neither new construction nor recent urban innovation are typical motivations for contemporary Grand Tour-ists to study in or about Rome.

Yet the large quantities of sheathed and erect scaffolding that currently veil famous facades beg renewed insights from the ancient city. For architects world wide, the problem of the "new" is continually relevant, pervasive, evasive, and the subject of desire. Rome's mayor, Francesco Rutelli, now boasts of 700 open dig sites, anticipating a growth in tourism that will draw those who seek revitalized historic monumental sites. Yet architectural practitioners bemoan the lack of political initiative or public dollars sponsoring new construction. One wonders if Rutelli's new Rome will be as captivating as this year's Largo Argentina or Via del Corso, which resemble mini-Times Squares; where 5-storey ads for the new Smart car and enormous portraits of Luciano Pavarotti and Dario Fo advertise the bank or product that has sponsored the historic facelift occurring beneath. The superimposition of ephemeral structures on these permanent artifacts provided an apt image for the problems of the persistent "città nuova", any city that has gained currency through time and seeks perpetual change. Knowing what's new in the Eternal City seems the inquiry of choice at the cusp of the millennium, when Rome will usher in the papal jubilee.

As a collection of emerging tendencies, the work exhibited by the ten teams provided the appropriate catalyst for considering both the revitalization of the stressed-out city and new signs that respond to its stresses. This assemblage of works from across Italy is the result of theoretical investigations by their authors that defy the pitfalls of ide-

ology, despite the post-modern ideologies that most of these architects were raised on. Neither built nor un-built works are intended for a life on paper, but address new social conditions, explore specific physical and cultural terrains, and innovate with material tectonics. Among the exhibited works, I was struck by the corduroy-brick texture used by Cino Zucchi to delineate his single-family house in a Milan suburb. I found the figure and its surface at once novel and familiar. I later discovered his horizontally-staggered brick coursing in both Italian vernacular buildings and Canino's Palazzo degli Uffici Finanziari in Naples. Zucchi's detached steel canopy with slender columns defines the groundscape and contrasts with lightness the weight of the elongated mass.

Many works in "Nuova architettura" are inspired by creative responses to historic references or urban conditions. Pippo Ciorra cites Luigi Moretti's Casa Girasole as an influence in his Senigallia commercial infill project included in the show. With clarity and elegance, the new three-story structure continues the piazza facade, separating *piano nobile* from *piano terra*, and responds to axial clues from the site. Meanwhile, the inner *cortile* behind the folding facade reveals the sublime intervention of Ciorra and Salmoni. The palazzo doubling in the MuMI Museo Michetti at Francavilla by Ricci & Spaini infiltrates historic embankment walls by introducing a submerged section on the site of a former Dominican monastery. Memories are invoked, or perhaps created, by the gesture which replaces a new roofscape piazza for that which was destroyed in World War II. The orientation of the addition serves to reconnoiter the various axes of the monastery and a prior main street, and converge internally to characterize the exhibit area. One is reminded of the refreshing Genoese interventions of Franco Albini, who, with simple aesthetics and careful planning, united vital museums out of dusty fragments.

Zardini and Meyers' humorous, yet perceptively critical, redefinition of the "picturesque" is a delightful departure from the seriousness of the other nine participating design groups. Still, it encapsulates common aims of the others in insisting upon the acceptance of individual expression, substituting specific "landscapes" for more abstract notions of "space", and marking their claim to a theoretical breadth underpinning the search for a new architecture. Their versatile call for "heterogeneity of the contemporary city [which] is not simply an aesthetic fact, but a political, social, and ethnic one" includes acceptance of the ordinary, recalling the recent interest among American architectural theorists in the writings of Henri Lefebvre and Michel de Certeau.

So apparent are similarities in the aims of this Italian generation to that of my own American one that we often ignore potential comparisons. The exhibit will perhaps interest American audiences for our differences in perceiving and addressing our shared urban dilemma. We are jointly imprinted by Pop Art and Arte Povera, the growth of global economics, feminism, the Vietnam war, disillusionment with the political establishment, and rock-n'-roll. As architects, we share a perplexed longing and an acute critical sensitivity for our modern forms and values, and in particular with the cities they have generated. Beyond their knowledge of so many works of the grand and complex modern legacy unique to Italy, this Italian group was weaned on Rossi and Tafuri, and they now assert that "all one can do is emphasize his own subjectivity." The city of types does not really exist, so the City of

Collective Memory is a facile fiction and the Teatro del Mondo is homeless.

While specific buildings and landscapes from Italian cultural tradition offer more than studies of types or avant-garde dreams, this generation must redefine its own objectives. Ciorra, in his public address, identified four problems frequently confronted by himself and his collaborators: the single-family house; the (false) dichotomy between landscape and nature; the viability, economics, and politics of public space; and physical scale. Eager optimism in the responses of the ten architects in "Nuova architettura" is evident. These most articulate critics of contemporary architecture are also those offering concrete and inspiring solutions.

Does a diverse body of Italian work founded on critical theory add up to a succinct new direction? Does the combined presentation of this select group suggest a comprehensible formal dialect, a manifesto for the new *tendenza*? Such expectation is unwarranted by their very arguments in favor of a diversity of individual visions. Neither is the intention of the exhibition to define a new style or name rising stars, but to identify new signs, and revise architectural methods and values. The exhibited projects put forth alternatives to grand visions dependent upon atopic idiosyncrasies and ideological defenses for the lack of poetry in crafting buildings. Rooted in their urban loci, these Italians seek new expressions in conscious manipulation of sound architectural themes, with creative composition and fine craft. While the group is loosely defined and only vaguely in agreement, they share with us the lyrics of Hendrix and the love of the cities they live and work in, especially those that change.

Pippo Ciorra

Laminations – Ten Concepts

As in the literary collages of the protagonist of *La Torre di Babele* by Antonia Byatt, the works of Italian architects in the generation between the ages 40 and 50 are not the result of a linear formation, of a continuous, uninterrupted transmission of theories, experiences and trials rooted in a form of social thought and a cultural program. They are, instead, the result of the inevitable direction taken by Italian architecture once it became clear to everyone, or at least to all those who were willing to notice, that the *rationalist* thought that had guided architectural research over the last thirty years in Italy—and for a long period in the world—had finally come to the end of its cycle. And that its postmodernist "derivations", along with historicism, neoeclecticism and the return the vernacular, have run their course more rapidly, with episodic and counterproductive effects for the constructed landscape. The linear flow of knowledge and technical expertise has been interrupted. The "young" Italian architects become aware of their role as inevitable factors of discontinuity, and turn their attentions to their own history, their own territory and the international architectural panorama with new eyes. Their own history, made of urban civilization and cultural movements, of "masters" and monuments, is observed with a simultaneously pious and disenchanted gaze, ready to deconstruct it in thousands of stories and situations, thousands of figures with which to establish particular connections, local dialogues. As far as our "territory" is concerned, or namely the complex of human intervention and the geography of places, this group of architects has practically opened its eyes for the first time, "discovering" the territory, revealing a "physical" context that is distant from any model or any pretence of forecasting, laying bare the uselessness and inadequacy of the tools of the various disciplines that claim to "design" it. The international architectural scene, finally, is observed by these architects with curiosity, but without ingenuousness. They are aware of the specificities of Italian architecture, due to the complexity, density, stratification of our country, different from all the others. But they are also aware of the evident global character of many of the phenomena that impact the contemporary city, which is therefore reflected in the vocabulary employed by those who seek to provide a form for these phenomena.

The most surprising result of these re-thinkings, in an architectural scene that everyone hastens to define as eclectic and immobile, is the coherence of the conception of urban space that lies behind the works of the designers presented here. The most interesting aspect is that of the identification, through addition, of a range of themes that make it possible to come to grips with the questions of the "contemporary landscape", of architectural expression, of the techniques of transformation of the territory.

The horizon of their work, therefore, has been defined by a series of successive, independent dissections of the physical and cultural

landscape, both in terms of time and in terms of spatial complexity: "layers" that take their places, one atop the next, as in the cut-outs of Byatt's Jane.

The city

The opportunity for this catalog and this exhibition is the result of the intent, on the part of the most important association of North American architecture schools, to focus attention on the *New City,* and therefore on the series of phenomena that characterized urbanized space today. The conference on this subject is held in Italy, one of the most indicative countries for the study of new—as well as "old"— urban forms. The conference is accompanied by an exhibition, documented in this catalogue, featuring the work of those Italian architects who, more than any others, have made the focus on the contents of the "new city" the center of their work in recent years. As occurred for the neo-rationalist generation, the foremost "negotiation space" between these works and the society is still the idea of the city, the ability to understand the complexity of what exists and to transform it into space for design work. But this time, the shared choice is that of no longer attempting to replace the real city with another city based on rational models and ideal relations. Instead, the emphasis is placed on finding tools and methods with which to know and describe the existing city, to somehow become a part of it, to play a real role in its continuous transformation. To "superimpose" one or more "laminations" that make it possible to have an effect on the city's most crucial elements or shortcomings: the ethical quality of public space, the aesthetic quality of architectural space, the urban quality of residential space.

Public space

Anyone sector professional who observes the urban phenomenon of the "imperfect city" in which we live notes, first of all, the evident qualitative and quantitative shortcomings of public space implicit in this urban form. The causes for this are well-known and comprehensible. First, the lack of available areas and resources for public clients, together with their incapacity to orient growth and transformation, in relation to the driving force of individual, private development initiatives. The city develops and is transformed in point by point, large or small interventions, and the administrators do not have the political clout or the operative tools to regulate this growth and the resulting social fabric through an adequate planning of public spaces. One of the essential themes found in these works is certainly that of a redefinition of the very concept of public space, an enhancement of collective quality in private spaces, a replacement of the old models of spaces of encounter and relation—the square, the porticoes street, etc.—with a range of new figures and new techniques, for temporary transformations, to give form to the nature of the space of conflict between the private and the "public".

The "landscape"

Another indubitably new factor is that the setting for these public spaces and the architectonic elements with which they are identified is no longer the *forma urbis* with its syntactic and analogical internal system, composed of axial, spatial and figurative relations, but the "contemporary landscape", with its languages and expressive techniques. By landscape, albeit urban, metropolitan or "diffused", we mean that

complex articulation of nature (what's left of it) and residential, infrastructural, productive and service elements that constitutes the contemporary city; by expression, we mean the capacity to develop a language or a vocabulary capable of taking the place of the rationalist morpho-typological certainties; by technique, we mean the capacity to identify the scales and instruments of urban intervention. Where the space of encounter and relation—once known as "public"—is no longer a connected, integral part of the urban "solid", but a place of encounter and transition between the city and the landscape, between local vision and global perception.

The infrastructure
By now everyone seems to agree that the structural axis of the form and function of the new urban reality is naturally infrastructure. Streets, highways, railroads and other material or immaterial means of communication are observed by architects, today, from new, more complex points of view. At least three of these "observation points" are essential for a comprehension of the contemporary issues of the city and architecture. The first has to do with the traditional national approach, the formal approach, to the overdose of circulation infrastructures. Bridges, viaducts, tunnels, interchanges and intersections have always been treated with an aesthetic, monumental method. This approach should not simply be repressed, but integrated in a landscape design that takes it into account and turns it to advantage. The second has to do with the need to recognize the value, as urban structure, that today involves infrastructures that have neither an urban scale nor an urban architecture. The third involves the favored relationship that must be established between the "streets", in all their various guises, and the spaces of encounter, leisure time, recreation, commerce.
Hyperarchitecture, therefore, in the presence of hypercommunication.

Open space
In parallel to the issues of infrastructure and public space, we find the issue of "open spaces" and their new urban role. In recent years there has been much discussion of this topic, also on an international level, sustaining that the "urban open space" is no longer a space waiting for architecture (of a building or a "piazza"), but a resource and a theme in itself in the metropolitan landscape, capable of establishing a non-hierarchical relationship with edification, defining a 3D spatial identity. But all this is particularly true in the Italian context, weighed down on the one hand by a rhetorical, monumental conception of open public spaces, and on the other by an infinite legacy of "non-central voids": abandoned industrial areas, spaces left between infrastructural elements, large scale interspaces, consolidated urban landscapes in which it is impossible to intervene without conserving their character as voids. Some of the projects contained in this catalog are beginning to identify a strategy that is consistent with this conception of open space, bringing out its qualities, transforming it into a crucial accumulator of a public sense of space.

The "home"
Three themes connected to living seem to characterize the works of these architects with respect to earlier generations, connected to the idea of "housing" as a purely constituent episode of the urban form. The first has to do with the reworking of the concept of the collective

residence, with reference to certain experiences of the Forties and Fifties, in which the overall form of the project was based more on the sum of the quality of the individual homes than on a higher level of an urban (or hygienic) order. The second has to do with the revisitation of the teachings of much of the architecture of the Fifties, for residential use but also with a particular accent on formal and expressive research: Moretti, Luccichenti, Asnago, Vender, et al. The third, crucial point involves the fact that contemporary architects are finally beginning to focus on the theme of the single-family house. Here we are not talking about the single-family villa immersed in the greenery of outer suburbia, but a minimal yet dominant form of contemporary urban dwelling, which must be integrated with public space, and considered a real material with which to build, with or without architects, the city.

The ordinary
The idea itself of getting involved with the theme of the single-family house, as it exists in the urban/suburban national landscape, leads, along with other disciplinary consequences, to the question of the ordinary and the forms and techniques of definition of residential space that have defined themselves during the long years of slumber of architectural culture. Balconies and split levels, eaves and decorations, awnings and overhangs, together with an entire vocabulary of ornamental communication of outdoor space, are therefore transformed, as certain projects included here demonstrate, into an architectural language full of ideas and expressive force, capable of re-establishing the terms of a possible communication between architectural culture and the citizenry. We do not mean that the city should be made only of "tin", statues of the seven dwarves and pink flamingos, but we know that the disciplinary repertoire has, until now, obstinately avoided coming to terms with the problem of the real city and the signals or impulses—which are not always negative or anachronistic—it emits.

History
History and its teachings are very much present in the design paths of these architects. In one way or another, the history of recent Italian architecture lies behind much of their expressive vocabulary. There seem, however, to be two crucial references. On the one hand, the detached, inevitable relationship with the lesson of Rossi and his cohorts, given a heterodox interpretation, seldom connected to its scientific pretences, but with great attention to its intuitions on suburban monumentality, memory, the introversion of edifice-worlds. On the other, and this is what seems to emerge most clearly from the work, there is a focus on the Italian architecture of the Fifties. This subject is generally associated with a few important works of architecture and a major debate on urban planning. Instead, here it is investigated in greater depth, in terms of the expressive research conducted, as we said above, by figures like Moretti, Libera, Gardella, Asnago, Vender and many others. Careful explorers, capable of venturing toward the "margins" of the modern, and at the same time toward the outskirts of the national mainstream, whose attentions were concentrated, at the time, on the issues of urban planning.

The uncanny and the "new monumentality"
A few years ago, in 1992, Anthony Vidler published a book that captured, more than others, the architectural spirit of our time, defining it

with a term that is difficult to translate into Italian: *the architectural uncanny*. Strange, unreal, surprising, suspended between the triviality of the "let's make it weird" and the definition of a contemporary "sublime", but very appropriate to define an architectonic space/time that can no longer maintain its classic relations with the canons of harmony and continuity. Yet this term seems to meet with its ideal application precisely in the Italian metropolitan continuum, which is so similar, in its imperfection, to Shelley's Frankenstein as evoked by Vidler. One of the praiseworthy merits of the architects included here is the fact that they have grasped this condition and superimposed it on two permanent factors typical of Italian architecture: that of the "drawing" seen as the sublime yet faithful representation of the space of the design, and that of desiring to conserve a "monumental" role for public architecture, although the very concept of the monument must, naturally, be passed through all the filters and alterations we have already discussed.

Architecture and art
As Franco Purini has repeatedly reminded us, the forms and conditions of construction of the contemporary urban landscape are very close to the conceptual process of architecture and art. Nevertheless, we feel that this statement should be made more specific here, to clarify its meaning in this context. Contiguity with art, in fact, means an analogous project approach. And therefore the idea of having to make the design process more similar to that of the artist, who tends to interpret and alter the present through a critical process, superimposed on reality, a sort of redemption, based on antagonistic force and hypercommunicative action, with respect to his customary exclusion from the phase of planning of the existing world. But it also means a capacity for dialogue, a willingness to recognize the fact that other forms of expression have been able to grasp and narrate the space of the contemporary city with greater readiness and depth than architecture. The presence, in this book, of ten "urban" photographers bears witness to the need for this dialogue, and is a way of giving thanks, especially to the photographers, to those who have offered us meaningful images and materials, essential starting points with which to "jump-start" the very rusty engine of our disciplinary discourse.

Studio ABDR
Forms of Conflict

The choice of uniting professional practice and project research today in Italy is an economic and cultural gamble: the projects presented here are a reflection of these difficulties. Some of these are under construction, others are not, in spite of their natural vocation to be built.

One aspect of our work, for some time now, is that of hybridizing, to be continually suspended between tradition and innovation. In this, we search for a continuous alternation between innovative solutions and typological orthodoxy: a relative liberty in the use of materials imposed on more than verified layouts and compositional abstractions which modify and distort architecture conceived with concrete pragmatism.

Renewed attention has been concentrated on the problem of construction in an effort to arrive at an ever increasing precision in technical form. Construction and technical form: today this is the unavoidable research field which the architect must cover thoroughly without taking shortcuts.

Our projects cultivate the many limiting conditions which are imposed by reality, rules and regulations, a "buildability" factor, procedures and environmental conditions, as we are convinced that a project must be able to transform problems into figurative opportunities.

Paradoxically, we can affirm that without external limiting conditions, a formal outcome could not exist. The complexity of the project, therefore, is never a preconceived self-indulgence, but the solution to many conflicting problems that reality ascribes to the figurative solution.

In our work, the representational aspect has always had great importance, such as in the selection of color scales, the contamination with pictorial techniques and the use of watercolors. The architectural image precipitates in artistic representation and the interchange is reciprocal.

With the irruption of information technologies, traditional scaling of the architectural design has been substituted in a vertiginous process which makes the sketch precipitate into the non-scaled precision of computer-aided drafting. The forceful contiguity of the architectural sketch with computerized drawing and rendering represents a new drawing frontier with some risks: an impetuous process of electronic selection in which the little colored drawing made in the Daler notebook is weighed against the *unnatural* use of the computer, which forced towards under-utilization, becomes used to draw old-style single line plans and elevations. (1997)

Our proposal for the creation of a new IUAV faculty in the San Basilio area of Venice foresees the transformation of the opaque, inert mass of the Magazzini Frigoriferi into a great translucent opalesque prism, hypothesizing a rather radical volumetric transformation of the building into an almost a genetic mutation, an endogenous modification of the construction material. In the new organism, the architectural mass would remain substantially unchanged: its transformation into vitreous material would make the interior auditorium halls, conference rooms and suspended landings distinguishable from the other functions of the building, as liberated in emptiness yet set into the

structural and visible network of the new construction. In the new building, temperature and environmental conditions would be controlled through a complex bioclimatic outer shell with large glass surfaces and orientable shading devices contained in the airspace interposed between the external surface of the building and the internal structure.

In the second phase, the project founds its strategies in recontextualization, beginning directly from a strong and variegated complexity without renouncing that idea of an urban *machine* for studying, the idea of a complex organism which contains all of the interrelated didactic, working and research functions inside itself. It is an organism which peremptorily commits its presence on the quay to the function of being a strong urban sign.

The building is characterized by the accentuation of its nodal characteristics with the necessity to present itself as a hinge, as an unwinding point between different given facts, and at the same time, as a place of compensation for the diverse characteristics that compete to form the urban context. The building, without renouncing its already affirmed formal identity, assumes in this new phase a compositive role of differences, taking on different urban valences and sending them back out, well-evidenced, as an urban given, hybrid, mixed, bifronted. (1998)

In the project of the Citadel for small and medium businesses, an ample range of typological-figurative solutions and passive and active energy techniques are developed according to the high level of diversification of the single buildings, distinct for their locations and expositions as well as dimensional, programmatical and functional characteristics, and foresees a verification of the expected results through monitoring systems which can compare the efficiency and results of the different adopted solutions. The principle objective is to arrive at a high level of energy conservation in harmony with reaching an elevated level of environmental comfort.

The creation of an adequate environment is also assured by the general layout of the complex which distributes the buildings around a large green open space, to be utilized solely for pedestrian movement and which directly connects with a new public park.

Because of the complexity of the general plan as well as the functional and building programs of the Citadel and seeing the numerous limiting factors presented by the prefigured general assets of the urban surrounds, obviously not all of the buildings can have an optimal solar exposition. (1998)

Project for a Residential Housing Complex, Tre Forti, Porto Ercole

Maria Laura Arlotti, Michele Beccu, Paolo Desideri,
Filippo Raimondo with Sabrina Cantalini,
Gianluigi Mondaini
Edilizia Immobiliare Rio srl, Nuova Sila Costruzione spa
1991-1995 project
1997-1998 construction

Thanks to the implementation of the regulatory plan for one of the last buildable zones in the municipal territory of Monte Argentario, construction of this project was possible. The area is a portion of unbuilt land wedged between small apartment buildings and compact buildings three to four stories tall. The complex is characterized as a unitary construction which adapts to the complexity of the geomorphologic base and respects the environmental characteristics of the site.

The building includes eight small residential units for tourism of about 1,030 cubic meters. These are grouped according to the typical "stepped" house scheme and are distributed using a system of continual and irregular ramps which serve as a true "backbone" for the entire complex.

To the right of the ramp is the principle body, made of housing units partially superimposed on top of each other, creating terraces from the roofs of the lower units. This stacking only takes place over the service zones. The living rooms all have southern exposures and turn panoramically towards the sea.

To the left of the ramp there are two living units articulated in three volumes; these are also superimposed one on top of the other to take advantage of the sloping terrain.

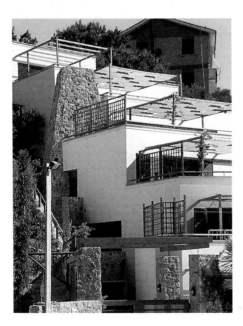

Detail of the sloping terraces

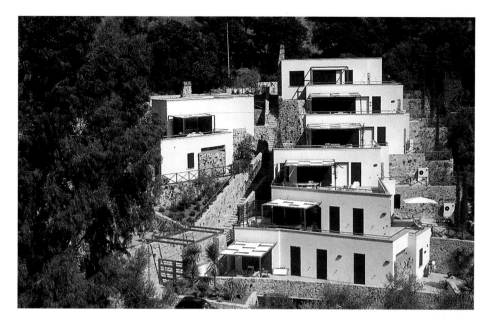

Overall view

Elevation

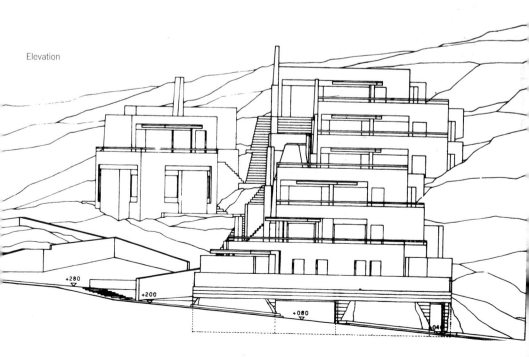

+280

+200

+080

Plans and longitudinal
section

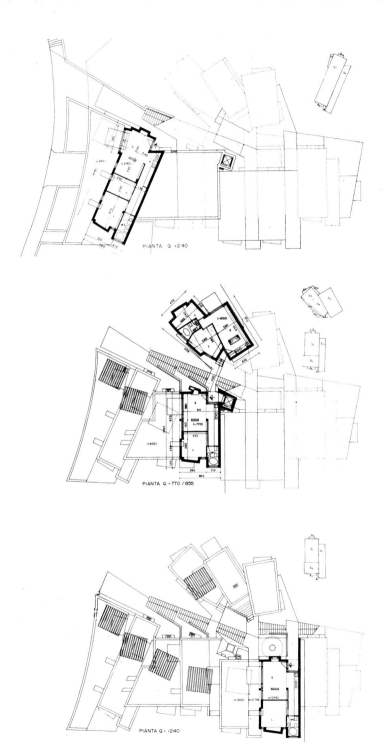

PIANTA Q +240

PIANTA Q +770 / 855

PIANTA Q +1240

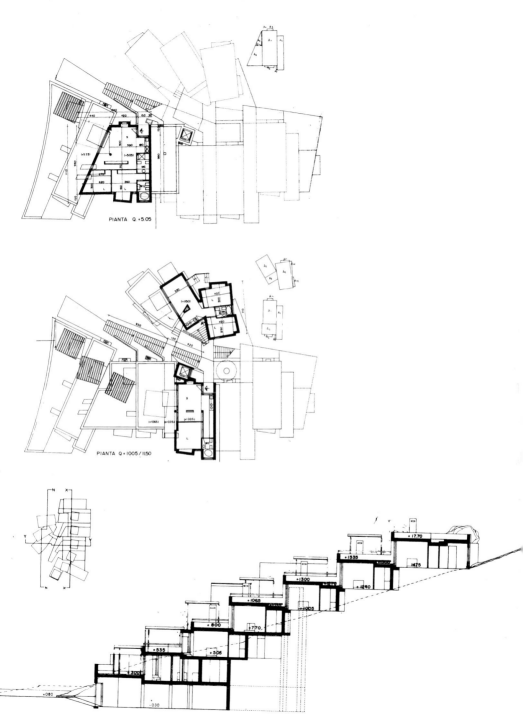

PIANTA Q.+5.05

PIANTA Q.+1005/1150

21

Citadel for Small and Medium Businesses, Rome

Maria Laura Arlotti, Michele Beccu, Paolo Desideri,
Filippo Raimondo, Architetti Associati,
A. Sciolari with G. Buzzelli, F. Cavalli, N. Iezzi,
C. Pennese, T. Sacramone, C. Siclari, M.C. Sorvillo,
S. Todde, G. Troccoli, R. Volpe
Nuova Fiorentini
Project under construction
1996-1997

The project intervenes in an area which has the same configuration today as it had in the Fifties for localizing the production activities of the Nuova Fiorentini factory. This area, which extends about 5.4 hectares, can be divided from a morphological and environmental point of view into two distinct sub-areas: the first is taken from the left-over area of the warehouses used for the plant's production activities (about 4 hectares), the second (about 1.5 hectares), irregularly inclined, is unpaved and partly covered over by vegetation.

Following the existing percurrence and hierarchies, the project develops in three parts: to the south, a pedestrian bridge connects a public park to an existing school complex on the other side of Via Fiorentini; at the center, around a large pedestrian piazza, a built-up zone is developed in a court scheme onto which offices, a hotel and general services face; to the northwest, a public parking zone, part surface parking and part contained in an existing warehouse, remodeled with the addition of a new floor. The layout of the central built-up zone foresees the positioning a series of buildings so that they design the large central space: on the east side along Via del Forte Tiburtino, a linear five story building outlines with its curvilinear form the entire piazza, opening the view towards the park; on the north side, a tower building with a total height of eleven floors closes the piazza and screens the experimental activities industrial zone as well as the multilevel parking garage; lastly, perpendicular to and with access from Via Fiorentini, a tower building, intended to be a hotel, with a total height of nine floors designs the profile of a pedestrian access ramp to the piazza.

Elevations on Via Fiorentini
and on Via del Forte Tiburtino

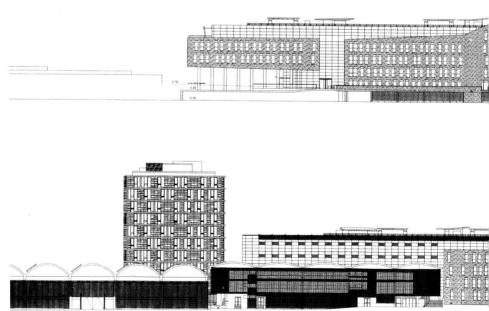

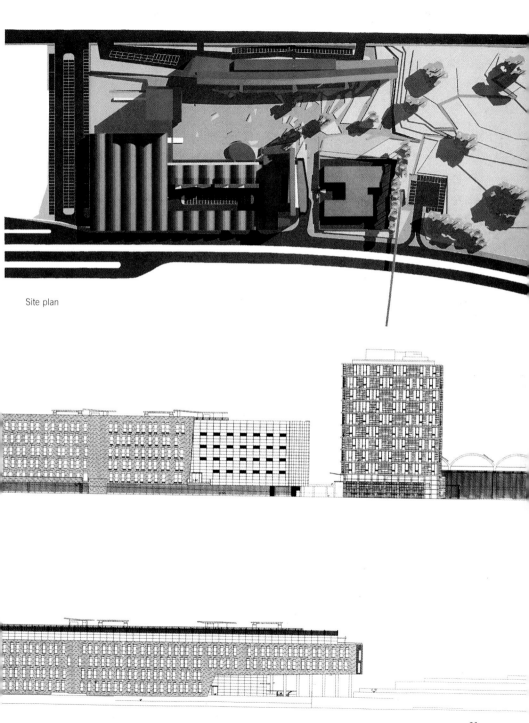

Site plan

Linear building. First floor plan;
upper floors plan

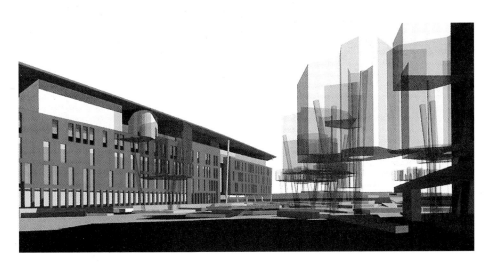

View of the "piazza"

Design Competition for a New IUAV Building in the Magazzini Frigoriferi Area of San Basilio, Venice

Maria Laura Arlotti (head of the project), Michele Beccu, Paolo Desideri, (ABDR Architetti Associati) with Stefania Aquilino, Maria Cristina Sorvillo, Stefano Tiburzi, Sergio Ruggeri, Marco Nardini, Giovan Battista Padalino, Domenica Rusconi, Kordula Ruh, Kadriye Saral
Model: ArchiDelta snc: Felice Patacca and Felice Ragazzo
Engineering: Ove Arup & Partners, London
Istituto Universitario di Architettura di Venezia
IUAV Servizi e Progetti
1999

On an urban scale, the project integrates and connects in a network The IUAV sites and university faculties present in the area through: a network of longitudinal and transversal connections and the creation of an internal piazza-atrium; the new urban street between the didactic region and the collective services; the provision of two new pedestrian bridges to the north and west; the requalification of the quay and its urban connections; the reopening of the street alongside the canal of San Nicolò.

On an architectural scale, the project is characterized by the net separation between the didactic-departmental region and the collective services region, the glass facade and the full height atrium; the internal distribution strictly correlated with the urban surrounds, the external distribution guaranteed by a lateral ramp, the different material aspect of the two building blocks and the bioclimatic functions.

The didactic services and department region is divided in three segments in order to attenuate the solar radiation incidence angle. Featured elements are the sequence of three halls for each floor, the groups of vertical connections and on the inside, the general services and studios.

The collective service region is made up of a main volume—inside of which are situated the volumes of the conference room and the auditorium—and externally by a ramp which runs along the west side, which permits direct public access to all three internal levels.

The layout of the exterior spaces favors the creation of an ideal microclimate in the open area behind the glazed prow which is further enhanced by the use of different construction materials.

Environmental well being in the building is assured by the passive bioclimatic functions and by screening direct sunlight radiation.

In the summer functioning mode, there is a refreshing breeze which is generated by the tendency for hot air to rise. In the winter functioning mode, thermal accumulation is produced which is generated by solar radiation penetrating the glazed surfaces.

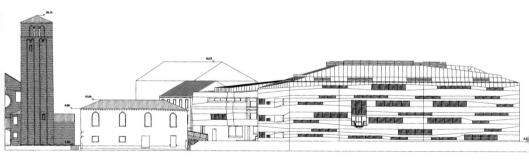

Elevations

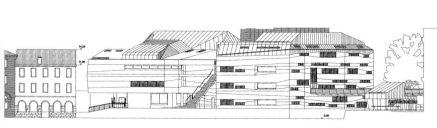

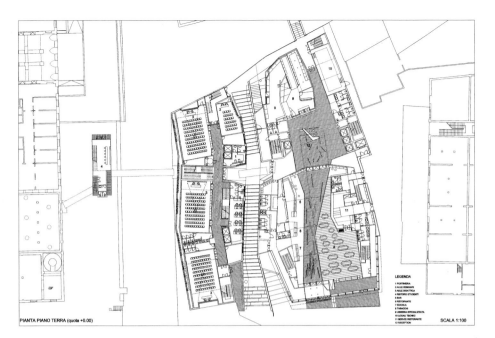

PIANTA PIANO TERRA (quota +0.00)

LEGENDA
1 PORTINERIA
2 AULE SEMINARI
3 AULE DIDATTICA
4 RISTORO STUDENTI
5 BAR
6 RISTORANTE
7 EDICOLA
8 TABACCHI
9 LIBRERIA SPECIALIZZATA
10 LOCALI TECNICI
11 SERVIZI RISTORANTE
12 RECEPTION

SCALA 1:100

Ground floor plan

Third floor plan

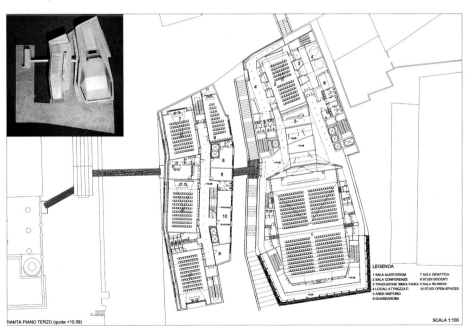

PIANTA PIANO TERZO (quota +10.39)

LEGENDA
1 SALA AUDITORIUM 7 AULE DIDATTICA
2 SALA CONFERENZE 8 STUDI DOCENTI
3 TRADUZIONE SIMULTANEA 9 SALA RIUNIONI
4 LOCALI ATTREZZATI 10 STUDI OPEN-SPACES
5 AREE RISTORO
6 GUARDAROBA

SCALA 1:100

Carmen Andriani
Stratification

Portable Borders
In the comprehensive ordering of the physical world, territory, ground and landscape represent the primary elements of its material conduction. In addition, combinations of often anthropomorphized by hybridized elements all make a contribution to defining a contemporary notion of landscape. This is generally understood as a transgression of the boundaries, both conceptual and physical, which were consolidated within preceding orders. The opposition of nature and artifice; the contrast between city and countryside; the difference between subsoil and topsoil, are elements which are no longer reflected in the physical realty around us. Our reality is configured, for the most part, as a set of dispersed and recognizable topographic pieces: from above everything is combined in a multiform tentacled continuum: mountain formations and construction, infrastructure and agricultural patterns, geometry and geography. Territory is subdivided following a logic of interstitial space and multiplicity which is difficult to relate to any clear geometric principle. In addition, the extent of the surface area is not clearly definable; it is continually becoming more difficult to trace a defined perimeter since space is often formed as a "leftover" and through rejection. Thus, as in the notion of "stratification", previously buried layers regain value and the problem of limits, not only in surface area, but also in depth appears.
As a result of the slow but implacable process of stratification, physical territory is the link between its history of modifications and the new interventions which, because they often operate in the "fully constructed" environment, are forced to use the type of spaces described above. So it happens that definitions and gestures traditionally attributed to the space circumscribed by the project, assume new meanings through of violation of scale.

Demolition (and Subtraction)
"Demolition" has a clear and necessary function in architecture. All cities have been constructed by peacefully and naturally demolishing previous construction. Destruction is a necessary precursor to construction, as if purging is useful to the health of a city. Existing construction owes its stability to processes of repeated stratification and the "illegitimate" additions which appear everywhere within the urban body, especially during this century. Demolition and construction are part of the vital cycle of growth and modification which makes the city belong to its age (the historical city was also contemporary) and which provides the stage for the exhibition those values, because while demolishing one knows perfectly well what will be built and how.
Conservation "tout court" of the antique is a concept which didn't exist in ancient times, or at least the concept didn't exclude the possibility of eventual dismantling. The bi-unique order of these two modes of construction—conservation and dismantling—guaranteed the harmonious growth of the city, preserving it from dangerous tendencies towards one or the other and

protected human memory, allowing for a kind of amnesia necessary to be able to "think of the other".

The contemporary city contains previously unknown types of space and spatiality: the omni-inclusive notion of landscape consumes everything which exists and revives a "pointillist" image of territory already globally and diffusely urbanized. Demolition of obsolete construction and buildings returns large areas, often centrally located, to the urban fabric. The results of this demolition are often large empty spaces which tend to retain this character.

The contemporary city fulfills its potential for transforming and giving meaning to these empty spaces, as well as open and negative spaces, interstitial and residual spaces. It is no longer possible to make use of the celebratory principles of robust rationality or to transform grand gestures of foundation into reality.

Constructing from Memory

The coherent dialogue linked to certain artistic figures and to the recent tradition of the Italian School, and in particular the "Roman", is the starting point for current project research. From this comes the concept of architecture as a tactile and material event, as visionary prefiguration, as stratification and contamination of heterogeneous signs and materials. Thus, we search for a new direction suspended between reason and abandon, geometry and material, tradition and transgression.

Architecture no longer constructs closed and internalized structures but works in an open, fragmented fashion, without reference to clear typology.

Typological recognition is usually based on single parts, on the formal autonomy of each part because of its material or technology (wood paneling, metal frames, stone walls, brick walls, structural glass, corrugated surfaces, keller grills...) Spatial construction plays with the duality of interior and exterior, utilizing superimposition and contamination of parts.

Construction through fragmentation, precarious equilibrium, immobile dynamism and proximity of unresolved opposites, in which empty space and "the space in between" are entitled to meaning: the reading of that complex phenomenon which goes under the name of landscape (urban, natural, artificial, cultural, coastal, horrifying, sublime, agricultural, dismissed, portal, archeological, suburban, marginal, fractal, fragile) have for several years constituted the extended territory of research, both theoretical and project-related.

Working with paradox or the alienation of traditional icons may be a valid strategy for intervention in these new project territories, consisting as they do of weak, marginal, ignored, peripheral and poor situations in the already-formed city.

The "critical" recovery of existing construction considers these areas, anonymous but known, as subjects for construction. The project uses that which exists as its starting point. The marks on the ground form and retrace what is often the outline of the demolished building. This new skeleton adopts the previous lay-out and unveils its own: the project must disentangle itself from this tight knot of marks, projecting some, canceling others, distributing new hierarchies and new weights and meanings...

GNAM
(Galleria Nazionale d'Arte Moderna)
Addition, Rome
1997 Invited competition

Carmen Andriani with Bruno Burnens,
Emilia Corradi, Claudio Fioramanti
GNAM

The National Gallery of Modern Art is on a precious site in the center of Rome, next to Villa Giulia, along a monumental path going by museums, historical villas, historical parks and natural sites. Our proposal aims to completion and modification of the unfinished project Luigi Cosenza did in the early Sixties. The task of acknowledging a clear identity to the new addition is achieved both through restoration and re-edification of some parts of the Cosenza project and through the addition of a series of brand new self standing elements, coming near, but not touching, the existing walls.

View of the model; plan

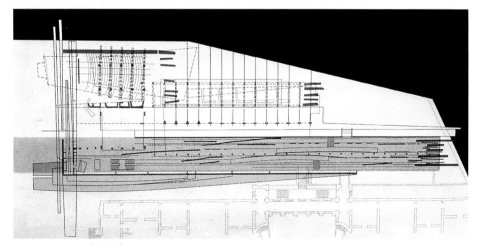

The exhibit's monolith

Design Competition for a New IUAV Building in the Magazzini Frigoriferi Area of San Basilio, Venice

Carmen Andriani with Giangiacomo D'Ardia,
Rinio Bruttomesso, Camillo Nuti, Andrea Vallicelli,
Donato Fontana, Alberto Mazzuccato,
Francesco De La Ville, Carlos Carrer, Bruno Burnens
and Andrea Antico, Paolo Faraglia, Susanna Ferrini,
Claudio Fioramanti, Vito Fortini, Alessandra Mazzei
Istituto Universitario di Architettura di Venezia
IUAV Servizi e Progetti
1998 First and second phase competition

The deconstruction of the new IUAV complex into several autonomous buildings, enclosed within a peripheral wall, is due to he complexity of the functional program and allows for different building phases.

The peripheral wall is shaped as an autonomous element: a cement frame constructed upon the traces of the demolished building's perimeter. Utility, vertical circulation and security system are located within the breadth of the wall. The wooden building is a narrow and long volume whose entire length faces the quay, and whose width is measured by the rhythm of the small studios hidden behind the large wooden facade.

The cross-shaped layout of facilities and catwalks is composed of two autonomous elements, both in structure and form: the former is made of brick and placed in continuity with the axis leading to the Magazzini Ligabue; the latter, along the classrooms wall, is a transparent element as wide as the catwalks.

The pavement, at the ground floor, will be modeled into a thickness of about 1.40 meters and it is the result of a superimposition of slabs of stone or cement. The water—contained in long pools—emphasizes the "composition" of single buildings and confirms the quality of a typical Venetian interior.

Conceptual sketch

32

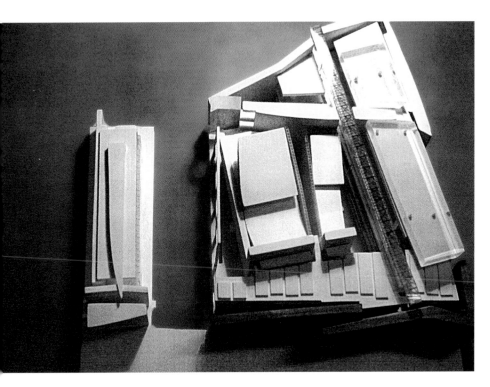

View of the model

Study on the architectural elements of the building

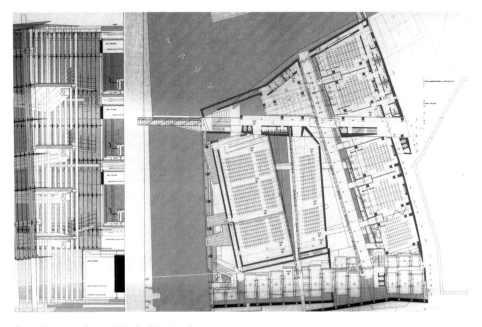

Plan of the upper floor and detail of the elevation

Section and elevations

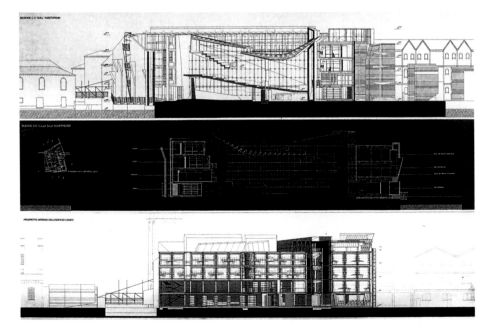

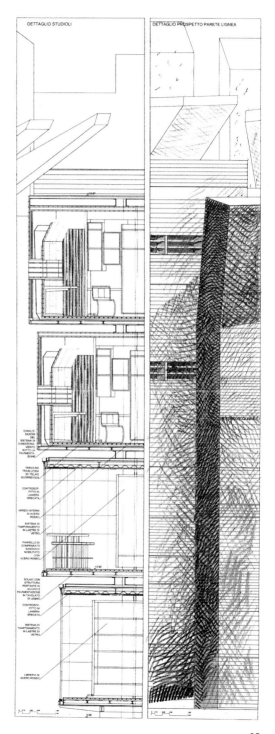

DETTAGLIO STUDIOLI

DETTAGLIO PROSPETTO PARETE LIGNEA

CANALIZ-
ZAZIONI
DEL
SISTEMA DI
CONDIZIONA-
MENTO
SOTTO LA
PAVIMENTA-
ZIONE

ONDULINA
TRASLUCIDA
SU TELAIO
SCORREVOLE

CONTROSOF-
FITTO IN
LAMIERA
GRECATA

ARREDI INTERNI
IN ACERO
ROSSO

SISTEMA DI
TAMPONAMENTO
IN LASTRE DI
VETRO

PANNELLO DI
COMPENSATO
SANDWICH
NOBILITATO
CON
ACERO ROSSO

SOLAIO CON
STRUTTURA
PORTANTE IN
ACCIAIO E
PAVIMENTAZIONE
IN TAVOLATO
DI LEGNO

CONTROSOF-
FITTO IN
LAMIERA
GRECATA

SISTEMA DI
TAMPONAMENTO
IN LASTRE DI
VETRO

LIBRERIA IN
ACERO ROSSO

Section through the professors' offices

35

Project for a New Parish Church in San Sisto, Perugia
1999 Invited competition

Carmen Andriani with Giangiacomo D'Ardia,
Paolo Faraglia, Claudio Fioramanti, Carlos Carrer
Italian Episcopal Conference

The building will be located in a suburban site in the outskirts of Perugia. The only interesting elements existing on the site are fruit and olive trees. The access road runs uphill along the site, allowing a view on the apsidal section of the building. Building elevations are based on a double layer of stones, tufaceous for the lower structure, limestone for the higher section of the walls. Interior space opens in a fan-shaped plan around the presbytery, leading to an apse entirely enclosed in glass walls, overlooking the garden outside.

Studies for the elevation

Side elevation

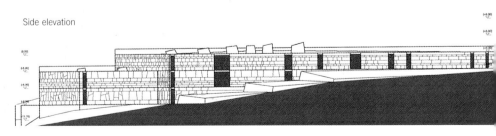

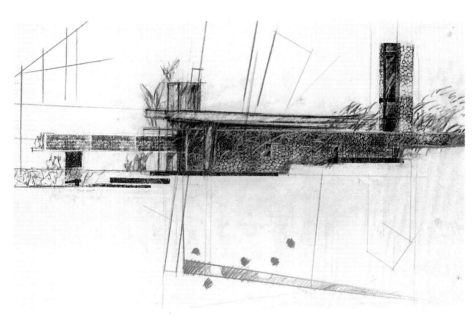

Studies for the side elevation

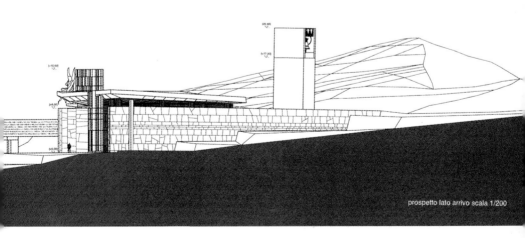

prospetto lato arrivo scala 1/200

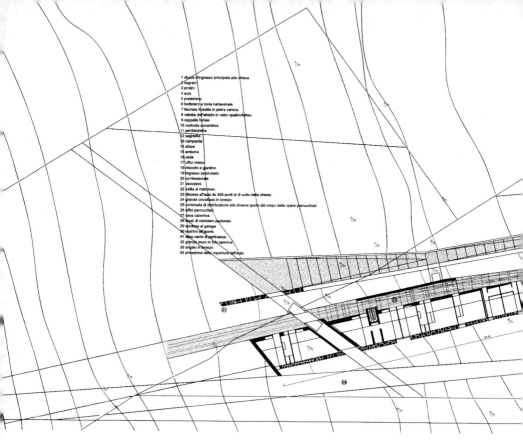

1 strada d'ingresso principale alla chiesa
2 sagrato
3 protiro
4 aula
5 presbiterio
6 battistero e fonte battesimale
7 facciata rivestita in pietra serena
8 vetrata dell'abside in vetro opalino/latteo
9 cappella feriale
10 custodia eucaristica
11 penitenzieria
12 sagrestia
13 campanile
14 altare
15 ambone
16 sede
17 uffici chiesa
18 chiostro e giardino
19 ingresso secondario
20 confessionale
21 devozioni
22 uscita al matroneo
23 discesa all'aula da 400 posti al di sotto della chiesa
24 grande crocefisso in bronzo
25 cordonata di distribuzione alle diverse quote del corpo delle opere parrocchiali
26 uffici parrocchiali
27 casa canonica
28 locali di ministero pastorale
29 accesso al garage
30 teatrino all'aperto
31 area verde di pertinenza
32 grande muro in tufo sperone
33 angelo in bronzo
34 proiezione della copertura dell'aula

Plan at the main level of the church

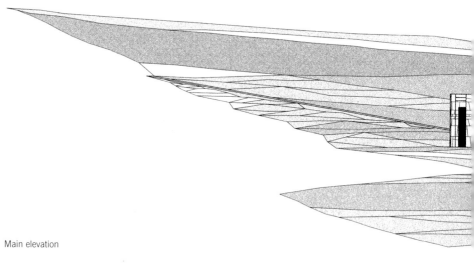

Main elevation

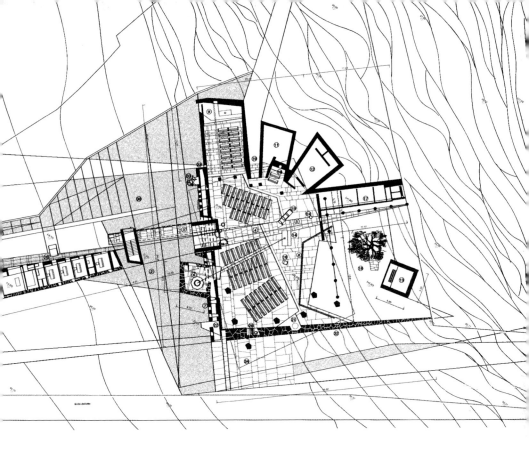

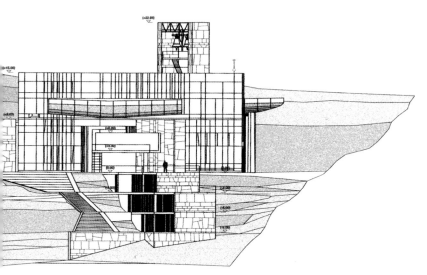

Aldo Aymonino
On the Edge

A shining darkness
Hanging on the wall of my living room there is a drawing representing an architectonic detail of a large outdoor enclosure surrounding a group of high trees. The drawing was done by Ludovico Quaroni, who was my professor in the final years of my university studies and the supervisor of my graduation thesis; the subject was the competition for a park in Bologna, which I had worked on with him and which won the first prize.
It was 1984.
If that image has been given a place of honor in my home, it is not to preserve the sentimental memories of my student life, nor to celebrate professional success. To me, that drawing has always represented the perfect synthesis of the two sides, one shining and one dark, of the job I have chosen to do.
On the one hand, I see the fact that that drawing was given to me as a present at the end of the competition as a gesture of acknowledgement and appreciation of the work I had done; it stands for the meeting and unexpected friendship of the aged master and one of his young students; the proof that it is possible to work in an enthusiastic and relaxed way; the validation of the hope that is always possible to continue to learn something from someone.
On the other hand, it constantly reminds me, over the years, of repeated disappointments (the competition led to nothing, as it was blocked by the Environmental Agency and today the renewal of this area is being done by an architect who did not even get into the second round of the competition).

It recalls broken dreams; the subdued but ever present pain of living and working in a country which has chosen to be built by "geometri"—building technicians with secondary school diplomas who are permitted to design buildings up to three storeys—and engineering companies (in Italy about 90 percent of the buildings built during the past thirty years have not been designed by architects), this resulting in one of the lowest standards of architecture in Europe. It brings to my mind the obtuse constraints set by people who are not interested in the quality of the projects and the mistrust and constant lack of acknowledgement of the work of the younger architects.

At the age of forty-six I remain, in comparison with European colleagues, a professional youth; I have built hardly anything and my studio looks more like a workshop than the place where a mature professional carries out his job, yet when I show my work, I attract attention.

Simultaneously, as a university tutor, I realize that, despite the objectively difficult academic situation, the work of the better students has no less intelligence or passion than that of their counterparts around the world.

In a country where the many (perhaps too many) architects are under-used, employed in bureaucratic unrewarding jobs, or living precariously constantly close to the edge, an obsessive passion for one's job becomes a defensive weapon against ethical and professional bodies which are often marked by a lack of curiosity about the outside world and by the fear of losing their few acquired privileges. It is a weapon which allows one to maintain the ability to look around, to experiment new ways to research and develop ideas, without accepting the end results, but instead going "deep into the unknown to find the new" (Baudelaire). It allows one not surrender to cynicism; to try to stay young for ever. (1996)

A Square in Decima, Rome

Aldo Aymonino (head of the project), Ezio Rizzuti
with Francesco Aymonino, Donatella Cavezzali,
Marina Cimato, Adriana Feo, Flavio Trinca
and Luigi Agi, Alessandro Baldoni, Giuseppe Catania,
Mario Sacco
Municipality of Rome
1996 Competition, first prize
1997-1999 Second phase

There are three different scales in the project: the monumental scale of the buildings and trees; an intermediate scale if the lamps (all with tops at the same height) and of objects such as the newspaper kiosk, bus stops, flower stand and police box; and a small scale created by the specific use of elements such as hedges, benches, paving, etc.

The elements in the project are thus the green areas, various paving, special lighting and small objects placed within the design areas. The quality of these spaces in also established by the varied uses of the areas and by the different paving in each of the three areas: the urban Piazza Vannetti, the children's playground from Via Bata to Via Castaldi, and the green area conceived as a garden between Viale Sabatini and Via Lordi.

The design is completed by a hedge at one end of the row of poplars forming a triangular prism crossed by a ramp joining up the various levels of the ground.

On the opposite side of Viale Sabatini towards Piazza Vannetti a triangular prism in Verde Alpi marble oozes out water to be collected in a basin made of the same marble.

The paving in the more pedestrian areas is made of travertine curbs and concrete. The link ramp is made of cement curbs and lawn, while the children's playground and strictly green areas are also lawns.

The newspaper kiosk, flower stand, police box, bus stops and lamps are considered to be "street furniture".

The geometrical logic is to close Viale Sabatini and open up towards the buildings on pilotis with continuous green areas throughout the quarter.

Lastly, a number of bronze cast sculptures have been included. Characterized by their "bent" surface and horizontal development, they are scattered throughout the square.

View of the model

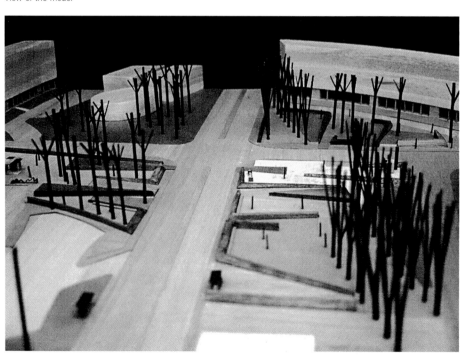

The "piazza" under construction

Site plan Detail of the "piazza"

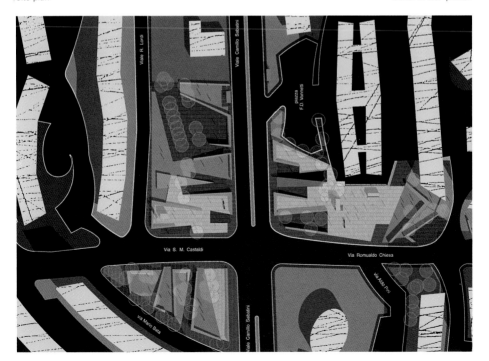

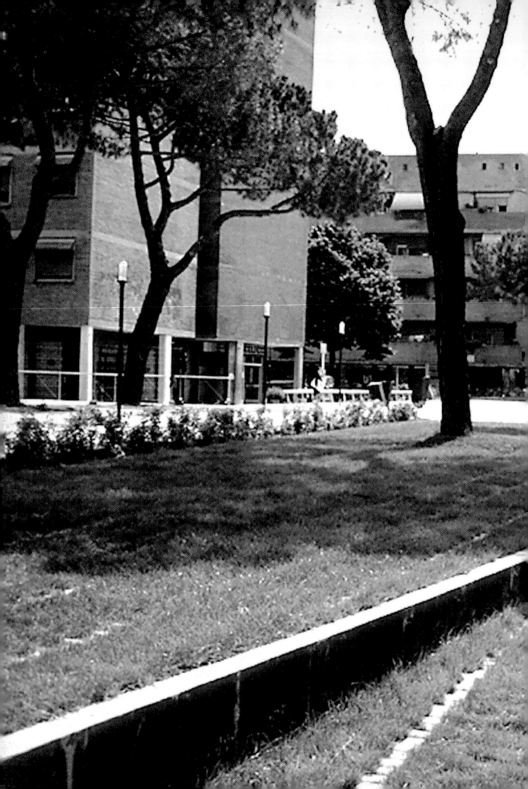

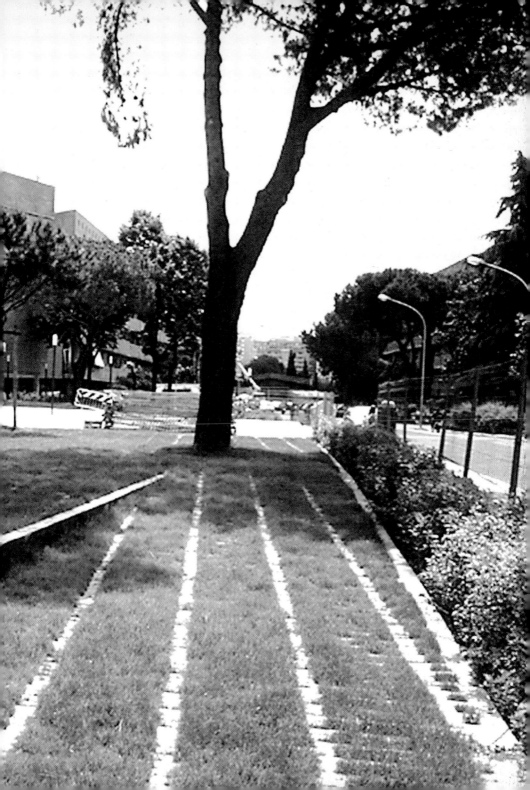

Wumawimbi Diving and Fishing Village Hotel, Pemba, Tanzania

Aldo Aymonino, Claudio Baldisseri with Adriana Feo,
Alessandro Baldoni, Anne Claire Beuchat,
Silvio D'Amore, Gabriele Mastrigli
1997

The project proposes the establishment of a tourist village along Wumawimbi beach in the isle of Pemba. The lot is 29,960 sq.m. The project consists of common buildings for the services and 36 bungalows (72 rooms) of three different typology.

The common service buildings are located in a strip orthogonal to the beach, so that both these and the bungalows can always refer to the sea nearby. This core is thought, in terms of plan as well as of architecture, as an independent unit, screened from the "residential" area.

The access to the village is through a track similar to the existing one which runs across Ngezi forest which will connect it with the site.

The reception area is the joint of the whole structure. The restaurant, the attached kitchen and the multifunctional building are orthogonal to it.

In the makuti roof of the restaurant there is a large opening which allows to save an existing tree. A large multifunctional space is located towards the sea; it is covered with a makuti roof as well. Inside, it is defined by a wooden wall and by a system of mobile screens which will divide the space according to the needs. The space may be used to show documentary films or films about Africa on a giant television screen, or as a playroom for children, or for a variety of other functions.

Opposite this building and slightly not in line with it, is located the verandah. It is a two-storey building and accommodates on the ground floor a shop and a small office for the organization of submarine-safari, excursions and deep sea fishing.

The portico facing the swimming pool is defined by large stone pillars supporting the wooden structures of the first floor, which is entirely in wood. The opposite part is designed by a sequence of detached and slightly not aligned walls. They will be vertical inside the portico and will be differently painted lilac-violet or sea green, whereas the side facing the bungalows will be slanted and stone-covered.

A wooden staircase leads to the first floor and takes to the bar dividing two areas.

The suggested swimming pool is level with the ground and has a depth ranging from 1.20 to 3 m as requested for the diving school. In a 30 cm deep section can be placed fixed deck chairs and another section will be equipped with a whirlpool. A small island is built inside the swimming pool with an open-air bar and a palm tree.

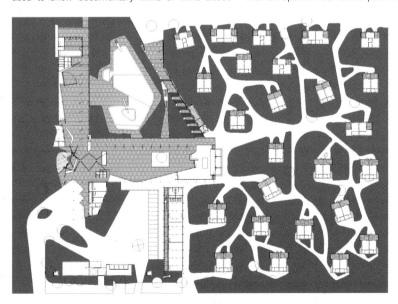

Ground floor plan

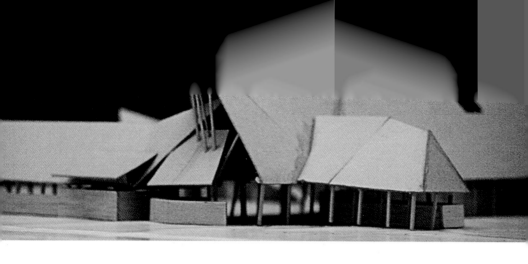

View of the model

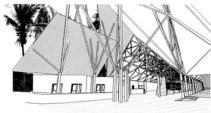

View of the roof structure

General view

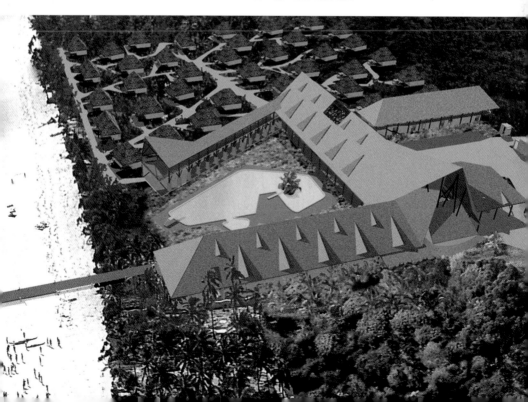

International Competition for the Extension and Replanning of the Prado Museum, Madrid

Aldo Aymonino (head of the project), Adriana Feo, Ezio Rizzuti, Flavio Trinca with Giulia Cerlani Sebregondi, Luigi Catenacci, Daniela Fanni, Simona Raggi, Paolo Sabatini, Roberto Sica
1995

The designs begins by redefining the existing relations between the museum and the surroundings in order to establish new spatial and functional connections with the other buildings. These are identified through a network of pathways and open spaces capable of creating a different use for the area.

What was also required was a key place in the project area where the dialectical relationship between the new elements and the pre-existing buildings provided the necessary premise for defining new urban spaces.

The solution was a new square with the parish church of San Jerónimo e Real, the bookshop, access terrace, entrances to the temporary exhibitions, and library.

This plaza becomes the symbolic center of the relation between old and new: a central attraction for the key functions in the area, and a meeting and resting place for both the horizontal and vertical circulation systems—the hub of the new museum structure.

The first step was to empty the Juan di Villanueva building of all the non-exhibition support functions and re-locate them in the volumes of the new extension. The several exiting entrances are united and placed to the rear, thus exploiting the natural lay of the ground in order to reach the main level of the building.

The two main pathways—one for individual access, the other for groups—reach the access area from the Calle Felipe IV front and from Plaza de Murillo, respectively. The plaza has been redesigned to accommodate unloading coaches, which will then be parked underground as part of the rationalized access systems.

The project is mainly organized by defining a network of paths joining up the different parts in terms of theme and function. The area in front of the main facade on Paseo del Prado becomes the main access for the systems providing reception facilities in a specially furnished space for visitors arriving at the museum from the nearby underground station or by private means.

Visitors can enter the main museum access on the Calle Felipe IV front or reach the exhibition spaces located inside the Army Museum and the Cason del Buen Retiro by taking a corridor equipped for small temporary exhibitions under the road.

Coach parties will enter by the main access on Plaza de Murillo, adjacent to the space described above and the access to the botanical garden.

A series of slightly sloping ramps leads to the covered access terrace—"a street of museum spaces." Another itinerary starts here and goes across the plaza to the temporary exhibition building and the library.

A network of pedestrian and vehicle service routes situated on a lower level ensures access for all the storage and transport functions required for the day-today running of the museum.

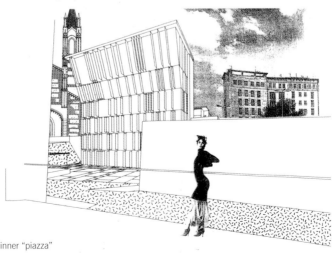

View of the inner "piazza"

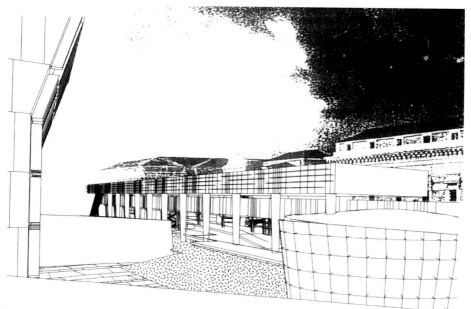

Perspective view of the new wing

View of the model

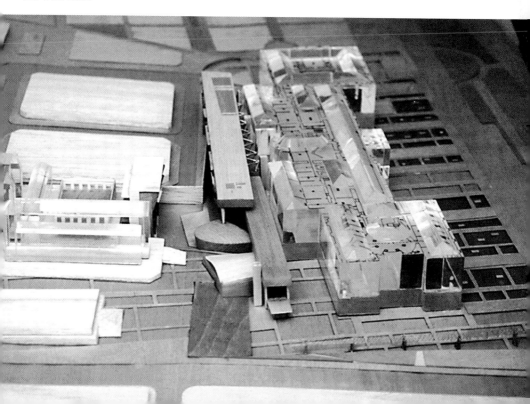

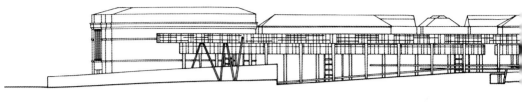

Longitudinal section

Cross section

Plan at the entrance level

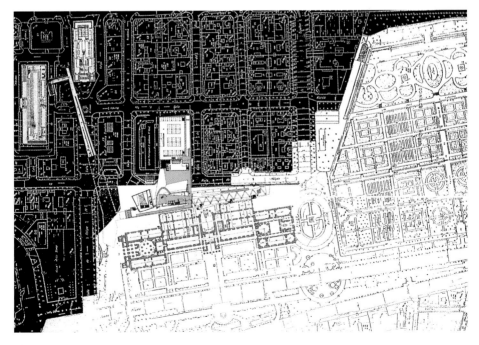

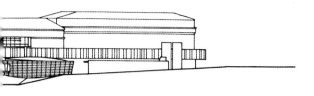

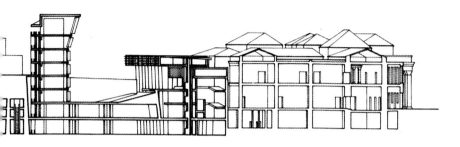

Site plan

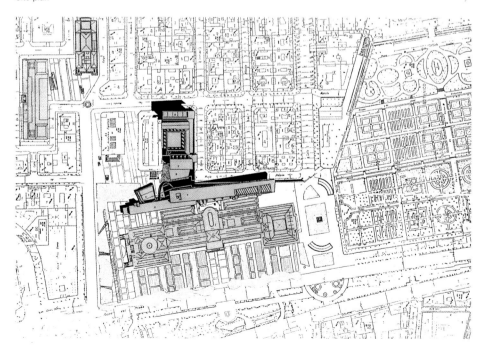

Stefano Boeri
Multiplicity

Thirty years ago, with the international success of three books—Aldo Rossi, *L'Architettura della città*; Vittorio Gregotti, *Il territorio dell'architettura*; Carlo Aymonino, *Il significato delle città*—Italian architecture seized the high ground in the field of architectural writing. Emerging of structuralist thought and of an accurate phenomenology of the historic European city, these three books gave voice to at least two generations of architects, critics, town-planners, which for a long period described a space marked by monuments, city parts, completed forms, territorial emergencies, homogenous urban textures, geometry of settlements, contextual relevance.

Manfredo Tafuri, perhaps the twentieth-century greatest historian of urban ideas, lent legitimacy to the dominance of this vocabulary through a ruthless work of transposition. In his *Storia dell'architettura italiana* (History of Italian Architecture), Tafuri chose, in fact, to ignore the fate of buildings constructed on the basis of designs (considered "exemplary" in themselves) by Gregotti, Rossi and Aymonino. Instead he told the epic story of the Monte Amiata Complex in the Gallaratese area of Milan, forgetting to describe the social wasteland into which it had sunk. He praised the eternal forms of the new Modena Cemetery, neglecting to mention the paradoxically rapid erosion of its plaster facings. He offered an interpretation of the forceful occupation of the land by the project for the new University of Calabria in the valley of the Crati river, but made no reference to the fact that it was never completed. In the meantime, while their virtual exploits were being celebrated in the world, Rossi, Gregotti and Aymonino knew how to seize an opportunity, in some cases cynically distancing themselves from the utopian ideas of their youth, and set off in more prosaic directions. But the buildings they designed at Perugia, Pesaro and San Marino had no one to sing their praises. Having followed their masters up onto the high ground, many disciples found themselves stranded up there, looking down with consternation at the ordinary buildings now being designed by those same masters, who had simply forgotten to tell them they had changed their minds. In the meantime, the city studied in those three books— already rendered virtual by the absence of any serious professional verification—had ceased to exist.

A multitude of building shakes run through the offshoots and interstices of Italian cities, occupying the countryside, fusing together centers that were once detached and spreading over coasts and valleys. Cities that no longer have edges, that look today like nebulas punctuated with a swarm of buildings standing in isolation or heaped together incongruously. The new urban dimension that has been laid over the top of the modern city examined in the books by Rossi, Gregotti and Aymonino, though without canceling it out, reflects a society where the number of people and forces capable of modifying space has increased enormously. And this in turn has radically altered the relationship between the principles of difference and variation that had been codified, thirty years ago, in the texts about urban morphology.

Today the principle of difference no longer acts between big and homogenous parts—the nineteenth-century city and the Renaissance one, the public spaces of the periphery and the great industrial zones—but between the individual molecules of an urban organism that has expanded enormously: between the suburban house and the adjacent shopping center, between the terrain vague and the adjacent block of apartments, between the car wash and the industrial shed with attached residence, between the bypass and the small area of farmland.

In the same way, the principle of variation no longer operates within broad urban sections (as a declining of the individual components of the city block, or of the linear texture), but through surprising jumps and extemporary solutions among the few categories of "urban features" that make up the emerging city: the variation is reduced to innumerable adaptations that can be assumed—in different territories—by the single-family house or block of apartments or container for a leisure facility/commercial undertaking. An excess of versions, then, that does not produce typological inventions and that appears to reflect the need for over-representation of the individual in a society made up of a plethora of minorities, loath to accept unitary and aggregated designs. All intent to distinguish themselves, without any interest in the public space that rests between the niches and precincts, where their identity is cemented. A society that has democratically constructed a territory that resembles itself. Italian architecture is today a field of knowledge with scarce social utility: having lost contact with the processes of construction of the territory and never consulted—even in situations of territorial emergency—by the political world.

And yet the Italian territory is now an extraordinary field of study and experimentation: a palimpsest of heterogeneous environments, where the new urban condition operates as a powerful matrix, meeting less obstacles than elsewhere in spite of the innumerable preexisting structures it intercepts. It is a landscape at the mercy of uncontrolled and eccentric forces which have undermined many of its traits, but it is also the cradle of experiences of urban life offering a glimpse of the future.

Alongside the chaotic invasion of single-family residences, the geographic imperialism of the great commercial enterprises and the standardization of historic cities to meet the demands of tourism, we can find highly advanced forms of ethnic cohabitation in some historic centers. In the diffuse city we encounter modes of living that have been freed from functional specialization, and we discover panoramas of unconscious beauty in the random points of contact between historic locations and infrastructures.

The themes for a new Italian architecture all spring from this novel and often "invisible" urban condition: in the capacity to intervene in mechanisms of individual variation that decline the poor typologies of the emerging city, in the care for new and temporary collective spaces which appear and disappear—like "flames"—in the territories of the dispersed city; in the attempt to use the economic power of certain building processes to produce a symbolic added value that could redeem them from their egoism.

Filament City.
The Proposal of a non Deterministic Urbanism

AIR Architecture International Rotterdam
Southbound-New Landscape Frontiers
1999
Hoeksche Waard/South of Rotterdam NL

Stefano Boeri with Giovanni La Varra, Gianandrea Barreca, John Palmesino, Maddalena De Ferrari, Angela Cortini, Isabella Inti, John Lonsdale.
Consultants: Marijke Beck, Marinus Kooiman (historical survey), Luca Bertolini (geographical studies)

AIR Rotterdam asked us to develop a proposal for the island of Hoeksche Waard, in the south of Rotterdam. We started our work with a comparison: in fact, as some other territories located along the Blue Banana (as the Cotswold Hills, the Trossachs and Kent in Great Britain, Maastricht-Aachen, Strasbourg, the Regio Raurica, the Waldstätte, the Regio Insubrica or the "Chianti-shire" in central Italy), Hoeksche Waard is the potential space of a new form of urban habitat: close to the big European Metropolitan Areas, yet immersed in the countryside; grounded on single-family housing and tangent to the big networks of continental mobility. It could become the laboratory of a new urban lifestyle, faraway from city centers and next to networks, where the domestic realm reaches intimacy with natural and agrarian landscapes, as well as with the territory of fluxes. We proposed a new Hoeksche Waard habitat which unwinds through the countryside in bands of differentiated density. In each of the 11 filaments that compose the new city of Hoeksche Waard, single-family housing hybridizes with a particular activity: small industry, retail services, spare time facilities, offices, sports, experimental agriculture, etc.

The territorial constraints guide the unstable and unforeseeable evolution of the 11 filaments within an amplitude of possibilities. Each filament runs along and progressively covers the profile of the dikes according density and overall extension rules. Yet, as with the genetic code of living forms, it is not possible to completely predict their evolution. A hindrance, a veto, an obstacle, can make the filament change its direction, which can indeed generate multiple figures in the territory.

Each filament grows according to its own rhythm and follows an unforeseeable evolution dynamic. In order to orient this growth, it is possible only to prefigure a limited number of ways of changing and some general Evolution Diagrams.

For the inhabitants of a space that alternates contemplation of the landscape and automobile movements, day by day life is organized by physical and perceptive differentiated bands; moving from a domestic intimacy with open landscape, each movement through and in Hoeksche Waard produces a particular sequence of filaments, a particular succession of resources and urban facilities, a particular sequence of perceptions.

New relations between housing, roads, dikes

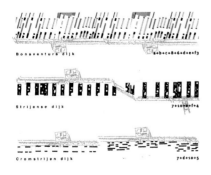

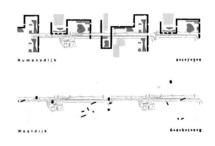

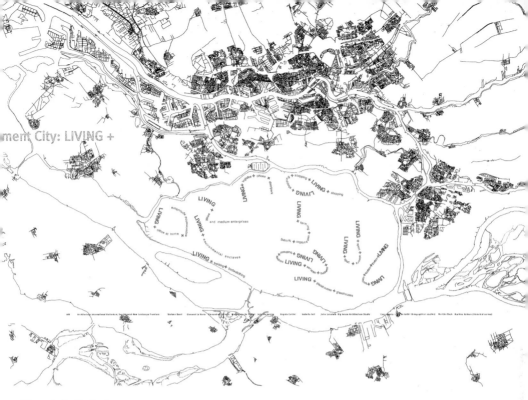

ment City: LIVING +

Filament city. Masterplan

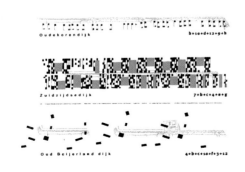

ENEL. Project for the Architectural Qualification of the Bagnore 3 Station, Santafiora (Grosseto) 1997-1999 (Under construction)

Stefano Boeri with Gianandrea Barreca, Nicola Bianchi, Luca Bucci, Giovanni La Varra, Andrea Viganò

On the hills of the Monte Amiata, in central Italy, a big geothermal plant for the Italian public electricity company ENEL is under construction. ENEL asked us to "landscape" the new geothermal power station, or better to hide it. This "landscaping" had to take place after the two large rectangular volumes of the plant had already been built in the first phase.

Instead of camouflaging or concealing the station with a sort of landscape make-up, we decided to offer a different view of it. We designed a sort of carter, able to redefine the identity of the entire building. We proposed to build a system of Cor-Ten steel ribs of various lengths (from 55 to 62 meters), self-supporting and hanging above the plant building, together with two large steel panels to protect the two short sides of the cooling towers.

The large hanging structure creates a relation between the two plant buildings and the cooling towers, thus making the overall settlement a complete figure, while the inclination of the beams was calculated to follow the slope of the mountain. The two buildings are given an image better suited to their insertion in the steep rocky slopes of Monte Amiata.

The idea was to give a clear identity back to a machine that offers today an anonymous image. To give it back the dignity of a big infrastructure, able to interact with the wild landscape that surrounds the plant. Simultaneous acts.

Urbanism as screenplay.

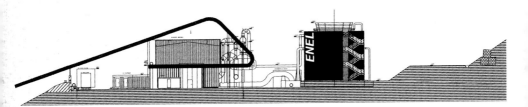

Cross section

Site plan

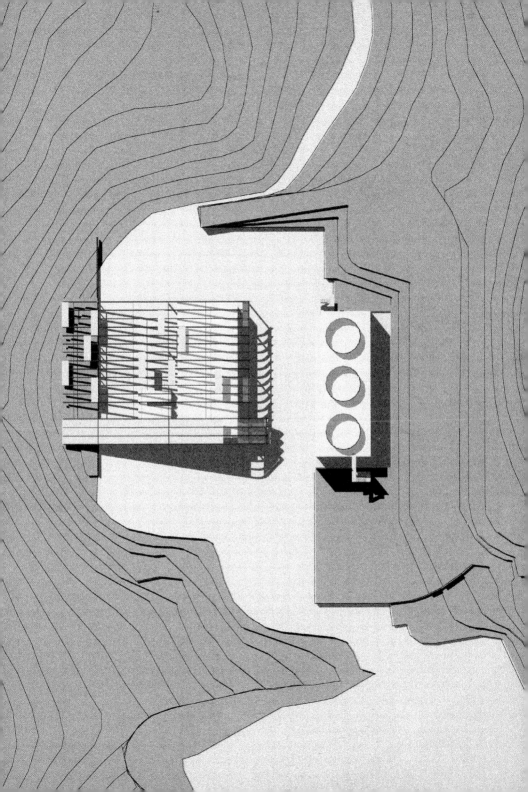

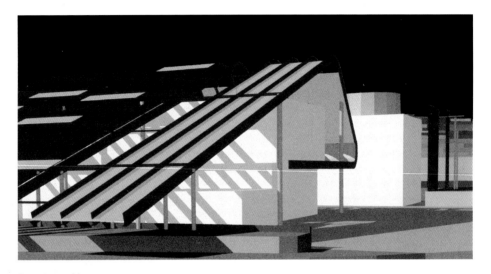

Computer model

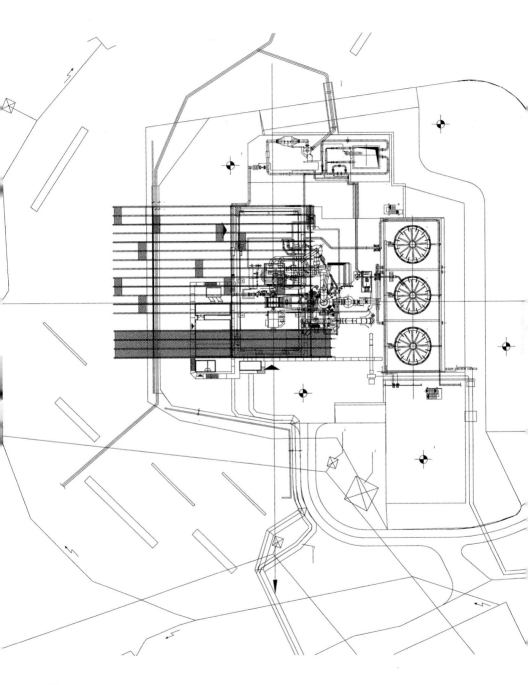

Ground floor plan

Harbour District, Naples Temporary Pedestrian Terrace.
(Molo Beverello, Piazzale Angioino, Calata Piliero, Molo Immacolatella Vecchia), 1997-1998

Stefano Boeri with Gianandrea Barreca, Giovanni La Varra, Nicola Bianchi, Luca Bucci, Claudio Finaldi Russo. Collaborators: Petra Legermann, John Palmesino, Filippo Sesti, Ivan Carmosino, Alessandro Cimmino, Christian Fogh, Elena Rosa, Luca Rovero, Claudio Sabatino, Giorgio Santagostino.
Consultants: Francesco Jodice (photographer) Lucina Caravaggi with Teresa Sorrentino (design of the open space), Leonardo Cavalli (mobility and parking), Riccardo Fossa (3D)

In Naples we tried to experiment a new strategy of action, in an area of the port adjacent to the most dense part of the historical city. Our objectives were to increase the tourist area while contemporary creating collective spaces in an incredibly dense city lacking wide open spaces. To solve both these problems, we proposed to start simultaneously with three different strategies of action, that usually follow one another chronologically.

Three projects were developed in parallel, simultaneously, on the same portion of land: an "urban renovation" project on the entire passenger area, an "architectural" project in the central portion of the passenger area and, at last, an "executive project" to create a temporary public space in substitution of the wall that separated the port from the massive presence of the Maschio Angioino castle. The intent was that of simultaneously dealing with various levels of the discourse involving different interlocutors.

A wooden deck 15 meters wide and 150 meters long between the town and the Port has substituted the wall that once separated them. The deck is a sort of "life boat" that becomes the line of demarcation, a border line between port and city. It is built with economical materials, wooden construction planks and scaffolding pipes, that could be easily disassembled and reassembled elsewhere. The function of this element, besides being a "balcony" of the historic center on the port area, is that of prefiguring a new possible relationship between port and city making it virtually impossible to abandon the process of transformation proposed by the other two projects. The temporary deck, as clockwork, locks the time that passes from the beginning of the planning process for the port of Naples and measures its delays, reveals detours and renders, in a certain way, irreversible a process otherwise easily obstacled.

Wooden pedestrian terrace. View from the city

Detail of a temporary pedestrian terrace (Stefano Boeri
with Gianadrea Barreca, Nicola Bianchi, Luca Bucci,
Giovanni La Varra, Claudio Finaldi Russo. Collaborators:
Ivan Carmosino, Luca Rovero)

Aerial view of the harbour district

The terrace viewed from the harbour

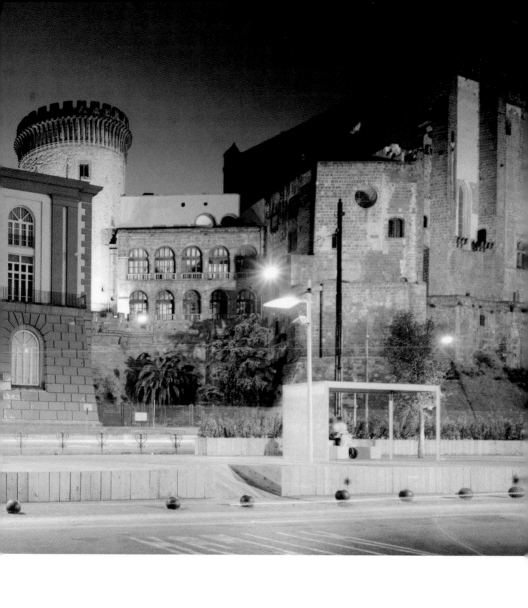

Pippo Ciorra
Publi-City

What is the ugliest
part of your body?
some say your nose
some say your toes
I think it's your mind
(Frank Zappa)

Architecture. Totem and taboo of the contemporary city
Landmarks and "creatures of the night"
At night, driving down the superhighways, the expressways, the ring roads that surround our cities and cross our *metropoli* we are often impressed by the lights and the transparent effects of "new" works of architecture, cheerfully ugly monuments of the city of today, and of high-tech "all'amatriciana." Surfaces that are luminous and attractive by night, mute glazed concrete boxes by day, the offices, showrooms, business and shopping centers, the gas pumps with connected conference rooms, the more the merrier, represent to an increasing extent a precarious, ever-changing system of points of reference, an urban thermography incapable of sensing Vitruvian values, but infallible in the eyes of those who must orient themselves in the time and space of the metropolitan territory. Talking works of architecture for the hassled users of urban services, but in recent years also the subject of the attentions of those who want to understand and explain the city, as in the case of certain fundamental "photo essays"[1], and the analysis made by certain architects and urban planners who have finally understood the limitations and incompleteness of the traditional tools of analysis, and the false objectivity of thematic maps and bird's-eye views[2].
The result of these observations is that by now everyone seems to agree that the contemporary city has developed, inside itself, an "urbanistic" and morphological system that is different from the historical one, but also very different—and an alternative to—the systems studied and proposed by the modern design and planning disciplines. Contemporary scholars of urban phenomena know that they are now a part of a different, more complex culture of urban design, based on the system of the material and immaterial infrastructures, and on all those small, medium or gigantic landmarks mentioned above. Where often the "landmark is merely a fleeting glimpse through the car window"[3], unavailable for traditional morphological analysis, the bearer of an identity based only on a question of opposition to the enclave that is the destination of the motorist (home, workplace, etc.). But these scholars also know that all this cannot erase the specific characteristics of the Italian setting, the fabric of the historical centers, the density, the attitudes of urban life; it just makes them more complex, overlapping them with a second, perhaps rougher, more schematic level of urban studies, all too Weberian in its relationships with the world of production and the distribution of wealth. A bit less of a demiurge, and much less ideological, those who design must therefore be ready to intervene in the space "between" these two layers, in the points of possible breakage, in the territories abandoned by both

the old and the new city, inventing a quality of space and of life that can no longer be directly imported from the forms of the historical city, but which cannot, at the same time, be directly, *naturally* derived from the Internet or from sociology, from the laws of mass retailing or the need to infinitely multiply infrastructures.

New city and new architecture – Three theses
In an architectural civilization like ours, over the last half century, which has nearly always been reluctant to confront "questions of language"[4], there is still no clear discussion regarding the possible consequences of this urbanistic "revolution" in terms of architecture and the vocabulary of its expression. In other words: is it possible to identify an idea and a "form" of architecture that is more suitable than others in relation to this condition, or does the contemporary city legitimize a situation of "free-for-all", a tedious condition of "pluralism" in which each person continues with "his own research", and in which the Centro Torri by Aldo Rossi and the Bilbao Guggenheim have, in the end, the same "urban value?"[5] The ideas, and above all the designs that are presented on these pages are naturally here as an attempt to demonstrate certain theses, theses that are already evident in this preface.
The first is the importance of questions of language in the present discussion on the city and architecture, precisely because of the recognized value of architectural design and buildings as an instrument of communication, and because of the necessity that is entrusted to an increasing extent to architecture, like Balzac, to become a complete expression of its times. Symbolized, for better or worse, in the infrastructural node of Euralille and its works of architecture, we can recognize the existence of a link of mutual necessity between these "urbanistic" scenarios and the signs of even radical renewal found in certain contemporary designs. Above all, designs like the Bilbao Guggenheim or the museum by Libeskind in Berlin, which manage to provoke a reaction between the conceptual and "artistic" value of architecture typical of the American neo avant-gardes, in which architecture, by now, has assumed a "decorative" or commentary role, and a condition of life and urban form in the "sprawl", something that is new only in Europe[6], which also relegates "high" architecture to rare occasions, which are therefore inevitably "critical". Or designs capable of expressing concisely, as in the "post-industrial" projects of Bernard Tschumi or the "painful, bleeding" works of Coop Himmelbau, the impossibility of harmony between mature humanism and the elderly phase of the machine age, as envisioned in the mythography of the modern[7], resulting today in the need to propose "open", inconclusive projects, in which different forms and identities overlap without every truly integrating. Or design such as the convention center of Lille or the display-buildings of Nouvel, where the values of separation and autonomy mentioned above are redeemed by the capacity of the architecture to become, simultaneously, a media event and an urban event, influencing the public and private life of people with a wide range of techniques.
The second is the particular condition of the "Italian case" that superimposes a dynamic of "metropolitan" and global transformation that is amazingly

rapid and intense over a historical and urban stratification that constitutes the pre-existing scenario. The result is that almost nothing remains the same in the contemporary landscape, and therefore the repetition of forms, techniques, design strategies directly derived from the established city exposes it to a condition of total extraneousness or alienation, irreversibly, radically scrambling its meaning.

Ten years ago the building by Aldo Rossi mentioned above, the Centro Torri of Parma, gently warned us, with sublime irony, about the "new" urban environment around it, and the new type of "public space" that filled it. With a single non-contextualistic gesture, and a few small towers, Rossi let us in on all that we could possible absorb from a hypothetical "Learning from Padania" (the Po Valley and vicinity), while openly declaring the work's status as a point of no return, the ultimate possible paradox created by the contrast between a "walled town" and the efficient disorder of Po Valley sprawl. *Aprés moi*, Rossi seemed to be saying, comes a great deluge, and it is no coincidence that those were precisely the years in which he was personally involved in importing, to Italy, the post-rationalistic research of Peter Eisenman and the post-architectural investigations of Daniel Libeskind. A deluge in which, in recent years, we have had to learn to swim in order to catch a glimpse, in the chaos, of "islands" of reference, to begin to redefine our role within the discipline and the society. These islands, for once, are not physical or conceptual "enclaves", based on self-referentiality and ideal space[8]; they are places of accumulation of urban form and functions, where the many "cities" of the metropolis can coexist and meet one another in a non-hierarchical space, in opposition to the socio-architectonic hierarchy typical of the modern city, based on the sequence: historical center, residential neighborhoods, periphery, industrial zones.

[1] Many people are beginning to notice the importance of the work of description and documentation undertaken by photographers on the theme of the contemporary city, open spaces, the new characteristics of metropolitan space. Among others, we can cite he works of Basilica (G. Basilica, S. Boeri, *Session del paesaggio italiano*, Udine 1997), Olivo Barbieri (*Paesaggi Ibridi*, Milano 1996), Peppe Maisto (soon to be published in the series *Nuove* *Strade*, edited by Alberto Ferlenga for Clean).

[2] On this theme, for example, we can mention S. Boeri, A. Lanzani, E. Marini, *Il territorio che cambia*, Milano 1993 and the essays by Boeri, Ricci, Purini and others contained in M. Ricci, *Figure della trasformazione*, Ed'A, 1996.

[3] Cfr. C. Zucchi, "Landmarks Enclaves. Visione e struttura nella città contemporanea", in *Architettura Intersezioni*, 3, ed. by F. Garofalo.

[4] The theoretical and pragmatic importance of the contributions of Argan, Zevi, Quaroni, Tafuri, in successive eras and with different overtones, has always oriented the main focus of "cultured" Italian architects toward the *centrality* of the issue of the plan, with respect to that of the building, or of expression. See, for example, L. Quaroni, "L'urbanistica per l'unità della cultura", in *Comunità*, 13, 1952.

The third is that the condition of imbalance and lagging behind of Italy today with respect to the international scene forces us to reflect on and analyze our own situation. Such reflection cannot help but be a useful and positive development, especially if we approach the theoretical knots armed with a fine series of projects. Projects that may involve "research", in competitions, doctoral theses, "educational" work in general, or may be concrete works of design, given the fact that by now it is possible to mention a decent number of works of Italian architecture[9] worthy of interest and capable of representing, with success and originality, the new conditions of architectural design. Even the new geography of the architecture schools, partially influenced by the recent organizational reforms, and partially by the creation of a number of new, smaller, vivacious schools, permits a renewed educational approach in terms of subject matter and forms of research, more open to external relations. At the same time, the reasons behind our condition as late bloomers are becoming clearer. They are partially internal, due above all to the difficulties involved in going beyond, with canceling it out, the legacy of a theory of the city and architecture that forcefully conditioned the entire development of international research in the Seventies and Eighties[10]. And they are partially external, liked to the status of "domestic exile" to which the most erudite Italian architects have been relegated in recent years, viewed with scorn by private clients and with condescension by the institutions. The starting point of our work, therefore, is on the one hand an awareness of the fact that the urbanized landscape of Italy is now a laboratory of crucial importance. On the other, it is the realization that a series of recent projects, including some in Italy, can be observed to identify the "new materials" of urban design, in the forms of new collective spaces, new spaces of work, in the architecture of the infrastructures, in the "houses", etc.

[5] This appears to be the vision behind the collection of works by Italian architects published, by F. Irace, in *Abitare*, 367 (November 1997).
[6] On the relationship between sprawl and urbanism see, for example, R. Ingersoll, "Jumpcut Urbanism", in *Casabella*, 597-598, Jan.-Feb. 1993, and other essays by the same author.
[7] A. Vidler, *The Architectural Uncanny*, Princeton 1991.
[8] Cfr. A. Monestiroli, *L'architettura*

della realtà, Clup, Milano 1979.
[9] Cfr., for example, the designs published in *Casabella*, 645, May 1998.
[10] The story of this Italian "hegemony" is accurately narrated and analyzed in J.L. Cohen, "La coupure entre architectes et intellectuels, ou les einsegnements de l'italophilie", in In *Extenso*, 1, "Recherches a l'Ecole d'architecture Paris-Villermin", Paris 1984.

Camerino University
New Building for the Molecular
Biology Department

Pippo Ciorra e Massimo Perriccioli
Collaborators: Stefania Ciuffoli, Daniele Manzi,
Gabriele Mastrigli, Armando Minopoli, Francesca Tata

The site chosen for the new building of the Molecular Biology Department is in the Madonna delle Carceri district, on the north hillside of Camerino, along the street connecting the university town, inside and outside the historical center, with the railway station in Castelraimondo. The area is already largely occupied by university building and facilities and it is going to be the second university district in Camerino, according to a reasonable policy tending to move the scientific faculties away from the old medieval buildings of the hill-town. The specific site for the new department is a regular but sloping site, at the end of a short axis already housing a quite few university office and school buildings. The design of the new building, together with a proposed addition to the Department of Comparative Anatomy next door, gives the university the chance to transform the whole district into a new and more rational section of the university campus, creating new public and circulation spaces, fulfilling the parking requirements for the area, providing technological facilities for all the buildings in Madonna delle Carceri.

The new building consists of three two-storey linear wings running down the hill, connected—and at the same time divided—by a circulation ring also linking the main atrium, facing east and the other university buildings, and the library, facing west and the landscape. Inner circulation in every wing is based on a central hallway, running all the way the length of the building, generally separating laboratories from offices. The three wings are separated by a sequence of patios, allowing light into labs and offices, and providing secure fire exits for all the areas of the building. All the "special" elements of the building (stairways, elevators, service and maintenance rooms) are generally located along the intersections between the main circulation ring and the longitudinal hallways, whereas specific "public" program occupies the two eastern and western edges of the complex: atrium and small lecture room on the west elevation; library on the east side. Director's office and administration occupies a whole section of the main facade, immediately above the main atrium. The image of the building is finally given from the three long wings, dramatically running down the hill. The long and steady strip-windows, untouched by the inner organization of spaces, reveal and emphasize the sloping condition. The continuous metal roof, "folding" when the building gently folds to meet the slopes, both emphasizes the critical relationship between the morphology of the site and the layout of the building and creates a fifth horizontal facade, clearly visible from the historic center of Camerino.

View from the parking area

Main entrance to the building

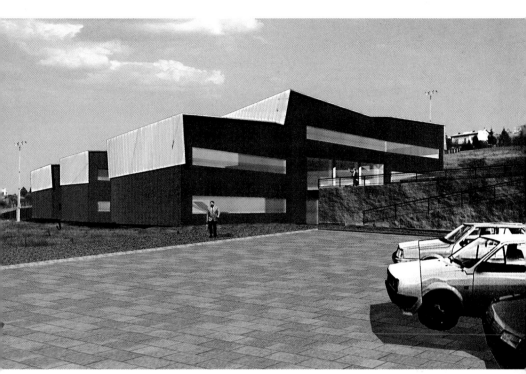

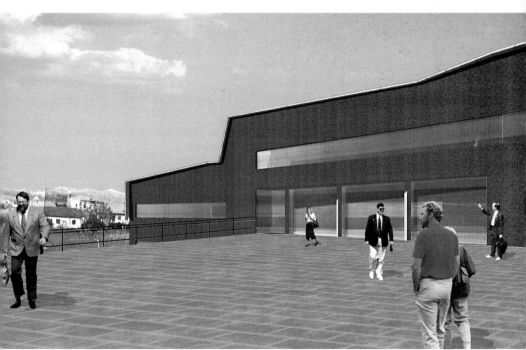

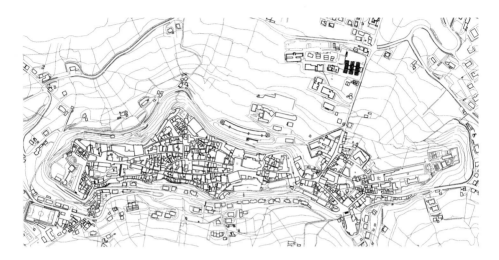

View of the building site in relation
with Camerino historic center

West elevation with the main
entrance to the building

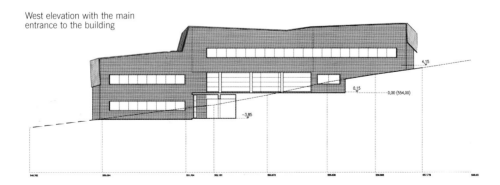

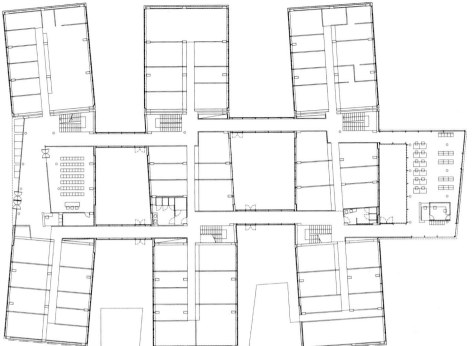

Plan at the entrance level

North elevation

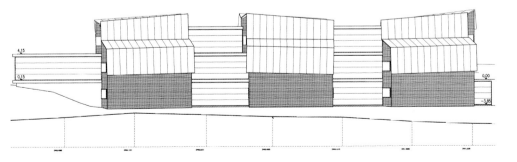

Office Building in Downtown Senigallia

Pippo Ciorra, Paola Salmoni, Giovanna Salmoni, Vittorio Salmoni. Collaborators: Chiara Marcelletti, Claudio Centanni
Structural team: Studio Barucca-Monaco-Spadoni
Client: Società Immobiliare Eden srl
Builders: Principi & Montesi srl, Senigallia
1996-1999

Senigallia is a sort of a little promise land town for contemporary architecture. Open to the new in its suburban neighborhoods, it also shows a mature balance between innovation and preservation issues in its valuable historical center. Especially in the monumental district around the ancient Castle and the eighteenth-century Fish Market, sitting between the residential grid and the coastline, there have been quite a few interesting projects concerning restauration, addition, re-design of existing buildings. The case of the dismissed Eden movie theatre, a 1950's uninteresting building sitting on a crucial site at the intersection of monumental streets and piazzas, the city allowed the client a process of complete demolition-reconstruction. On one side the new retail-offices three storey program couldn't be housed in the dumb and dark theatre box. On the other side it appeared to administrators that the site, just challenged by the new library designed by Massimo Carmassi in the old fish market complex, needed a "new" qualified architecture. The design is based very few critical elements. The first is the organization of the new building around a "void" core, a glass courtyard occupying the center of the site and allowing light in most of the spaces. The second is the memory of an old *passage* anciently crossing the site, connecting the castle to the Piazza del Comune. Though it was impossible to recover the old path, the gallery leading to the courtyard and the courtyard itself, both open 24 hours a day, extend the "public" condition of the piazza in the inner core of the building recalling the old urban situation. Third element is the open staircase (steel, wood, glass) occupying the fourth side of the courtyard, screening on one side the view of an ugly "backyard", emphasizing on the other the modern condition of the building.

Last but most visible element is the layered facade on Piazza Roma, a fragment of curtain wall apparently responding to office space organization then shaded by a second layer of suspended stone, responding to the monumental *esprit* of the context. The main elevation has again a double urban condition, partially facing the piazza, partially sunken in the narrow alley leading to a monumental square in front of the castle. This is reflected in the "uneasy" facade, quietly open to the piazza and then folding and detaching itself from the building in the alley.

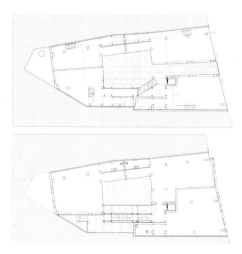

First and second floor plans

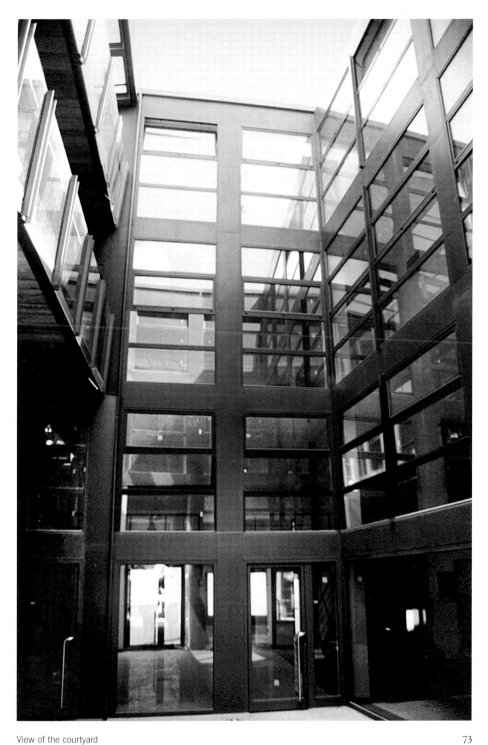

View of the courtyard

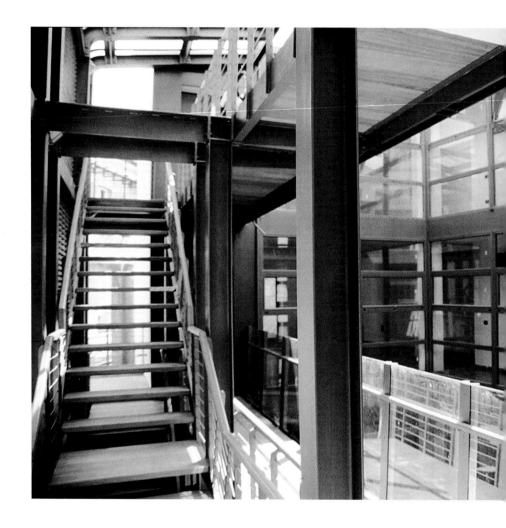

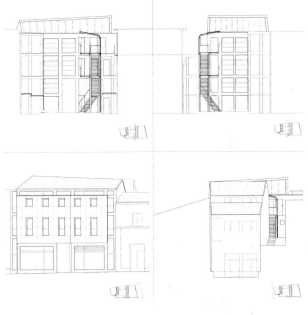

Alberto Ferlenga
Recurrences, Differences, Reuse

When projects and the places and times in which they are located are not clear, they carry no weight. I am not saying that this is always the case, but it certainly has been true for me since the way in which I practice architecture is profoundly influenced by a kind of "topographical curiosity" that turns every project of mine into the discovery and interpretation of a place. I do not know whether this a definitive and acceptable condition or a personal evaluation, but it seems to me that my work depends more and more on observing, connecting and interlacing the strewn pieces of the current landscapes. These activities also take into consideration the transfer of forms and spaces from one point to another in contexts that are suspended today between an accelerated homologation and the appearance of a new and, for now, imperceptible system of differences. What is certain is that the majority of contemporary projects are to be found in this area, and this is where placement and instruments must be redefined. It is of course always possible to close one's eyes and cut out one's own space and time somewhere between a carefully chosen past and a dreamed-of future. There have been periods in which architecture contributed to the construction of real landscapes by recomposing the fragments of past time or by imagining new scenes, uses and customs. Thus, the past and the future seemed to be within reach, prefigured by the rhythms of a colonnade or windows in cities transformed from time to time into museums or theatres. Today, the past and future are present in other ways: the past through a more detailed awareness that leaves no space for conjecture or free interpretation, and the future through the increasingly more amazing simulations offered by the cinema or virtual reality.

Other arts and techniques now satisfy our thirst for the past and future much more than architecture, ones that no longer pretend to change the real world; other instruments provoke the wonder and nostalgia that many buildings once did. And the real world, for its part, remains without interpreters, thwarted by the impossibility of finding models that are not always and only exceptions or absences. In many places it has been reduced to a heap of discarded materials, in others to a mass of worthless repetitions, depreciated because the pieces making it up no longer express new formal values, and because the better places have been degraded ever since their images have been exploited for commercial and tourist purposes.

Architecture seems to find itself at a crossroads: it can either become an artistic event and participate in the spectacle that permeates every contemporary human action in the economically privileged parts of the world, or accept a status of marginality and non-necessity, reduced to the exclusive task of refinishing. In either case, its particular field of action will be reduced and its role confused with that of others as a consequence of its inability to obtain beauty, comfort and order from everyday things.

We are constantly reusing forms and places.

The best places are contained within other places, like pearls or double meanings, and it takes the eyes of the viewer to discover them. Volatile and

changing, some of them vanish as soon as the light varies, or change meaning as they withdraw, leaving behind only obviousness and emptiness. Other more inconstant ones are transformed as the attention directed towards them changes. Those linked to distant geographies fill their empty beings with evocative names and suspended presences that catalyze natural elements and record every astonished passing. The more ordinary ones are manifested in the accumulation of the leftover materials of our times, wherever a particular use has left an indelible though invisible trace, or wherever pleasant architectural forms or spaces happen to have been formed.

It is difficult for the materials comprising today's landscapes to find a place in completed forms. The details in them are like secret places that alone can express an appreciable quality. In the details, as in the interstices or spaces generally between things, something similar to a value still stirs, and permeates the ordinary universe of architecture with an ambiguity that offers some hope. Only when the architectural or spatial fragments are separated from the framework they belong to are they endurable. Only when mutilated by incompleteness or neglect does the architecture of our times show the residues of aesthetic quality. Half-finished materials line the roads creating with slight differences houses, factories, bridges, and shopping malls, and once the final arrangement has been reached they maintain their indefinite state. Their inability to have a positive influence on the places they inhabit and to express any aesthetic quality is by now so widespread as to transform any construction into a single continuous amalgam that borders roads and surrounds voids. Nonetheless, differences do exist, and it is not simply a matter of the architect making a number of surface changes as many are wont to believe. These differences regard new approaches which are emerging from the fantastic compositions of that huge formal dump that makes up the urbanized landscapes of this poor world, or from the mixtures of old and new landscapes that distinguish many places in Europe where particular landscapes and age-old histories manage to resist the current functional and formal homologation, producing totally new architectural and territorial hybrids. They regard compositions of volumes and simple elements; they regard, albeit perversely, the importance that architecture continues to have in spite of everything. (1999)

Design Competition for a New IUAV Building in the Magazzini Frigoriferi Area of San Basilio, Venice

Alberto Ferlenga, Fernanda De Maio, Gianluca Mondini, Margherita Vanore
Istituto Universitario di Architettura di Venezia
IUAV Servizi e Progetti
1998

The design for the new IUAV building follows the plan of the Magazzini Frigoriferi, and refers, in its architectural aspect, to the ships that dock in the port.

From a volumetric point of view, the building is composed of three units covered with brickwork on the outside: "the ship", which contains the halls, exhibition room and main entrance; the "C"-shaped block of the departments which also houses the bar and bookshop on the ground floor; and the auditorium and restaurant block in the direction of the Giudecca. The three units develop around a central, glass-roofed courtyard that represents the core and atrium of the building from which there is access to the port, the Magazini Ligabue and the former cotton mill.

From an architectural point of view, the strongest element is that of the long "ship", which the two other components flank. Its metallic covering. sectioned on one side and rounded on the other, constitutes a luminous glass ground for Campo dell'Oratorio

Detail of the "ship"

General view

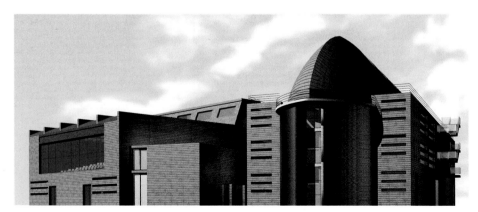

78

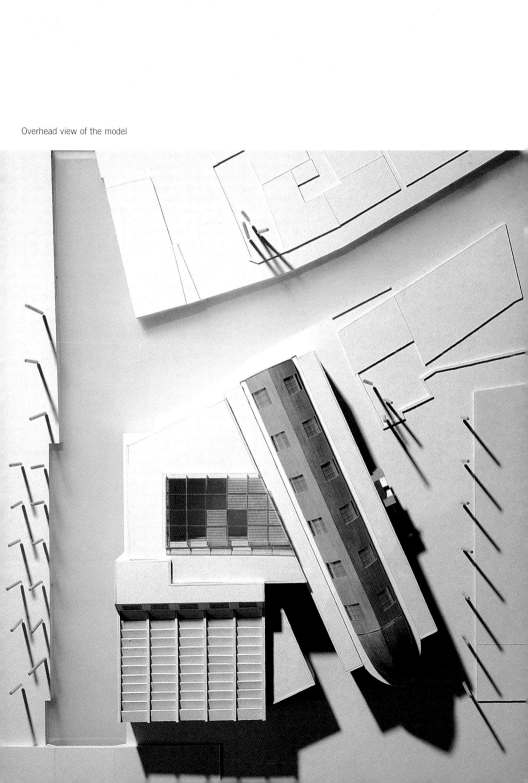

Overhead view of the model

Ground floor
First level
Third level

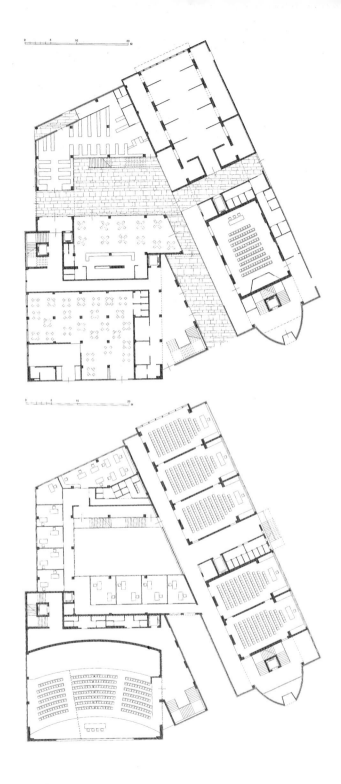

80

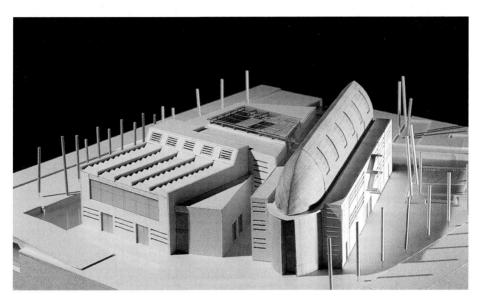

General view of the model

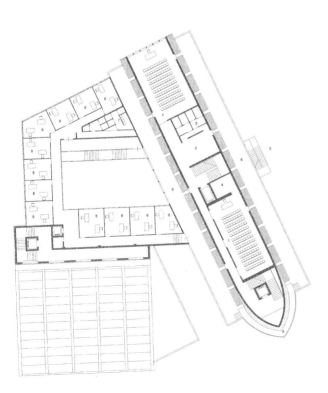

Design Competition for the New Town Hall, Bari

Alberto Ferlenga, Fernanda De Maio, Margherita Vanore
Municipality of Bari
1998

The design for the new Town Hall of Bari is based on the premise that no building could possibly compete with the dimensions and dramatic quality of the architecture in this part of the city. Therefore from an architectural and functional point of view it exploits the presence of the three gas holders of the old gasworks. Constituting the characteristic element of the new Town Hall, they house the atrium, a small auditorium, and an exhibition space. They emerge from and are reflected in a kind of piazza of water which emphasizes the expressive force of the structures.

The rest of the Town Hall is composed of two separate, articulated blocks covered in Trani stone which contain the offices, and which are connected by a covered passage alongside the pool of water.

General plan

General view of the public spaces

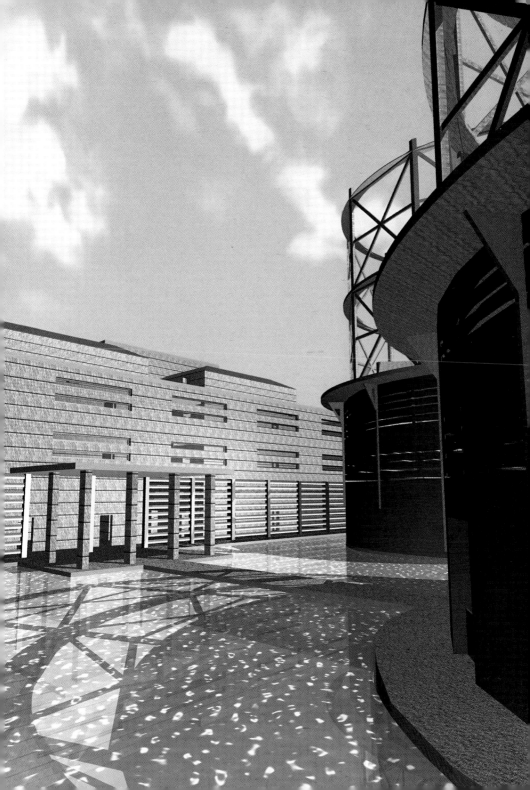

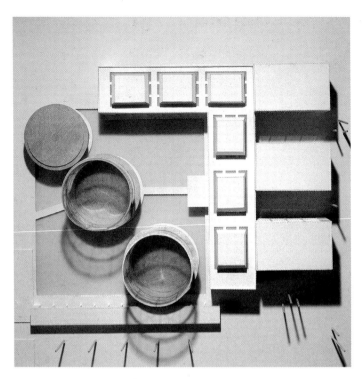

Overhead view of the model

Relationship between the new buildings
and the existing context

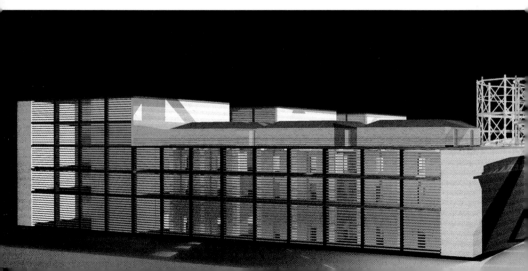

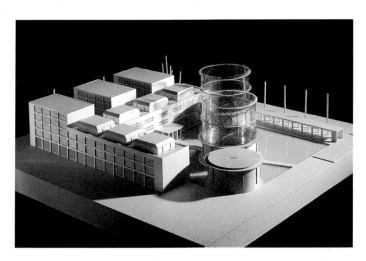

General views

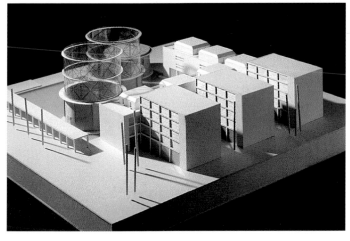

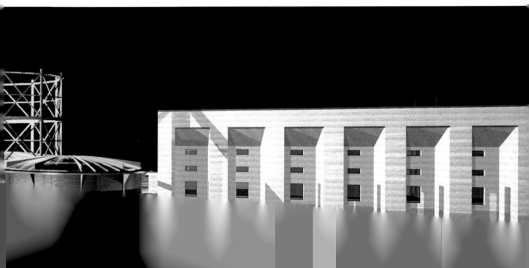

Design Competition for a Multi-functional Centre, Sondrio

Alberto Ferlenga, Gianluca Mondini, Franck Gautrè,
Nando Grattirola, Piero Balgera, Massimo Erba,
Carla Celli
City of Sondrio
1996

The project aims to satisfy functional needs (various services for the school campus) while creating at the same time a new center for the complex in which it is located.

Given the rundown state of the area marked by the presence of buildings devoid of any architectural qualities, and a degraded urban fabric, the buildings (a library, a canteen, and an auditorium) are placed around a long piazza. The idea of a single multi-functional container has been substituted by that of separate architectural and functional structures so as to constitute a small urban complex that can become the core of a campus as well as a point of reference for this peripheral area of Sondrio.

From an architectural point of view, the three principal blocks are characterized by the use of the same stone on the exterior and reinforced concrete on the interior. This is structured in different volumes which indicate their different functions as they emerge from the roof.

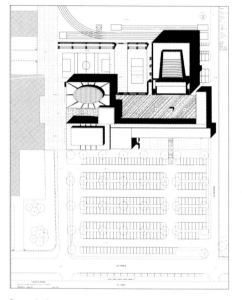

General plan

Overhead view of the model

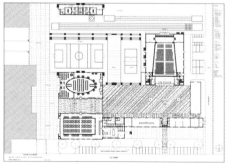

First floor

General view of the model

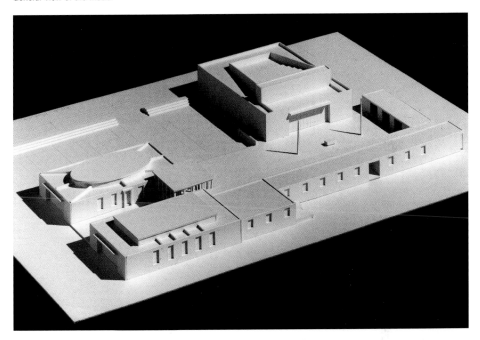

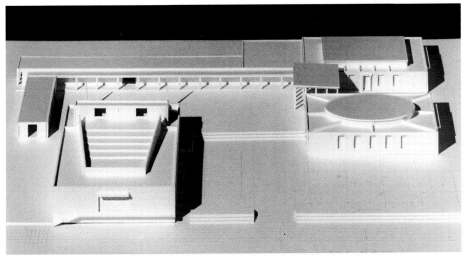

Ricci & Spaini
Out of Scale

The disappearing of the scale hierarchy is one of the most innovative aspect, brought about by the CAD system in architecture and urban design, from a conceptual point of view.

Working on the computer the scale is set only on printing session. However, on the computer the *zooming* lifts the designing level the constraints of a particular scale and work at infinite number of scales. The CAD revolution breaks all confines of scale and does not let any set scale truly confine the individual.

Moreover, from a designing point or view the computer receives and supplies with a simulation of reality, thus perception of the city is no longer "true". This theme is a falsification of space through the computer medium.

A video image is always out of scale. The use of a computer takes off the scale and replaces it with a new dimension, jumping the scale of work that corresponds to the physical evolution of the drawing and the theoretic design of the city.

When there is no sense of talking about scale to solve the issue of contemporary urban space, the project itself assumes a strategic role in controlling its physical transformation. And the aim to give a form to the new interconnection of different scales (economic, social, physical) in the contemporary city challenges the project towards a new measure *out of scale*. Where *out of scale*, differently from the past, is not a dimension referred to the functional or symbolic quality of intervention or to its structural role in the urban fabric. *Out of scale* means the needless of the scale relationships.

The contemporary conditions of the landscape is the result of a strategic manipulation at the large scale that is only evident when seen closer, such as of complex system of minimal interventions understandable only at the landscape dimension. To put together in a project all the different strategies and social fights that make the city change is an issue that forecasts the conflict solution in a physical shape that can represent an economical agreement, a quality aim in which people trust.

But if it is possible to refer to a determined scaled rapport to gather the formation of economic issues and social spaces, the design process has to avoid the fences imposed by its scale of intervention and assumes relations at the "multiple scale" to fully express the sense of the modification, refining the levels of interconnections ion between space and the various subjects involved to find new aesthetic values.

The multiple scale design, bringing simultaneously strategies and different measures to the attention of the planning decisions, places in crisis the traditional form of urban plans and, like what is happening in Italy, brings towards new instruments of interpretation. These new roles will be funded upon a "picture of coherence" between local issues and global networks and the estimated value of territorial effects of an infrastructural intervention. New instruments will be applied as well for the pre-figuration of the transformations of the space as an "agreement act" towards economic and social development of established environments.

By this point of view the critical points of local systems are *out of scale*, or better yet in local and global environment. The future has begun. The meeting points between the city fabric and the networks, material or immaterial, are the actors of a transformation of the physical impact of the urban space that shows the change of social habits and of structural economy of the city. These project are preferably developed based on a sector point of view or following the network needs, not considering the territorial effects, or opposite, are contrasted by a great number of bureaucrat obstacles that don't even consider the new instruments of transformation.

Transforming the nature of the urban design: from the objective of intermediate scale to the system of spatial interpretation of the new dimension based on the socio-economic process, seems like a direction obliged for the design process.

The other side of the coin is described in the last film of Peter Weir: make believe that the world finishes at seaside and live like Truman Burbank in a vase of gold fishes.

To fragment the image of the territory in a broken mosaic of development; to recognize the new figures of the transformation; to identify the areas where they are happening: these are the keys to read the contemporary attitude to the transformation of the human environment.

This is already a designing process even if nothing really emerge of a traditional urban project, nor of architecture, but at least it can generate a way to identify the design themes that link the contemporary concept and can take the continual transformations toward objectives of quality.

The first theme is that of the project as fragment. Since various possible approaches may be made to the contemporary city, the project must identify them as fragments in different systems of relations organizing the apparent chaos of recent urbanization.

A second theme concerns the configuration of public space as a fundamental value. Without it, there is no urban quality and no city. The third theme is that of the project as a multiple-scale strategies only clearly visible from close quarters, like complex systems of minimal transformations expressed only in terms of landscape, the project must go beyond the limits imposed by scale and establish multiple-scale relations to express the significance of the planned changes as well as discover new meanings.

Lastly, there is the theme of the expression of differences: the search for identity based on a specific local condition and the need to communicate with others through shared images of change lead to an understanding of the complex meanings involved in transforming a given place. These meanings are made explicit—at various levels of interpretation—through the form of physical space and its potential figures.

"La Reserve" Spa Hotel, Caramanico (Pescara), 1996

Mosé Ricci & Filippo Spaini,
Mario Masci with Carla Ghezzi
1992-1996

The building is set in the project area along the east-west axis. Two staggered main volumes are adapted to the contours of the site and the position of the site in relation to Orfento valley. The first partially underground volume has two levels: the lower floor with spa facilities (inhalation room, aerosol, mud room, swimming pool, gym, Turkish baths, services and plant rooms) at the hotel entrance level (lobby, reception, bar, restaurant, offices, kitchens, stores, etc.). The building has a pearl-gray stone slab finish in an aluminum grid and a flat roof providing an artificial terrace on the mountain side, thus attenuating the overall volumetric impact. The second four-story building is above ground and contains the hotel functions and vertical circulation systems. The cladding is Santa Fiora stone in an *opus incertum* pattern within aluminum grid looks uphill by means of a large window; the sloping roofs are made of copper. Seen from the north, the *opus incertum* stone facade has colors ranging from gray, green to pink-brown, thus echoing the wooded Apennine landscapes. The whitish-gray cladding on the southern front stands out brightly from the similar colored rock walls of the Orfento canyon.

Site plan

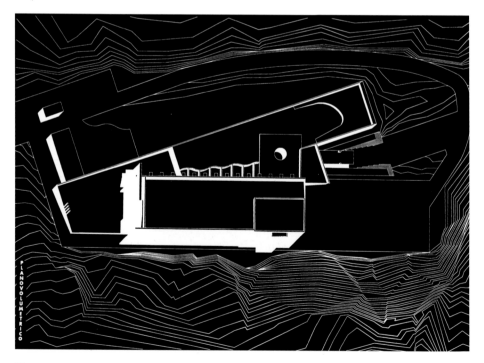

Main entrance

View of the rooms wing

Following pages, View of the building

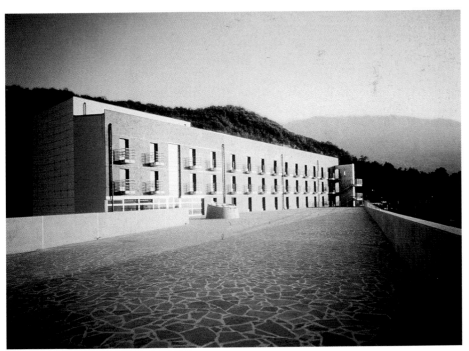

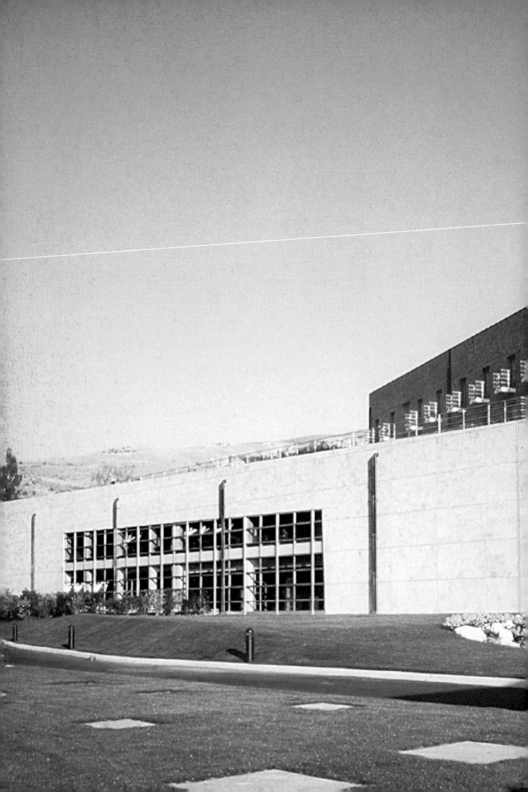

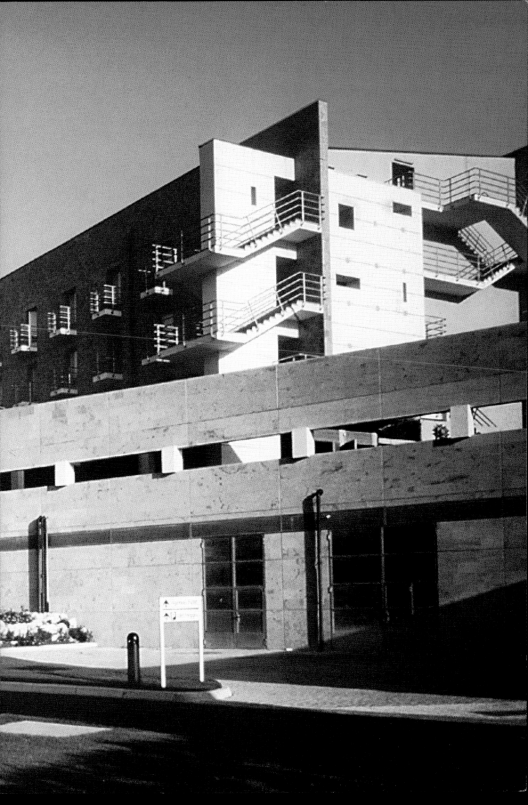

Michetti Museum (muMI), Francavilla al Mare (Chieti), 1997

Mosé Ricci & Filippo Spaini
with Carla Ghezzi
Municipality of Francavilla
1993-1997

The project is for the restoration and extension of the Dominican monastery at Francavilla to house a Museum of Contemporary Art. The new building is constructed in the underground space of an embankment behind the old town walls and under Piazza Rinascimento—the main square in the historic urban layout destroyed during the Second World War. The extension site plan includes the memory of the place by proposing two different positions for the architectural elements in the project. The first governs the dimensions and structural procedures and corresponds to the former orientation of the piazza main street. The second is oriented according to the axis of the monastery and is the position for the functional elements. The building axes are staggered in order to create a complex dynamic internal space for the exhibition itinerary round the double-height central room and to ensure the subsequent transformation into the new irreducible architectural elements in a unitary design.

The museum space opens outwards by projecting its white stone walls beyond the building to the paving of the piazza and the town walls.

The "piazza" on a roof of the excavated museum

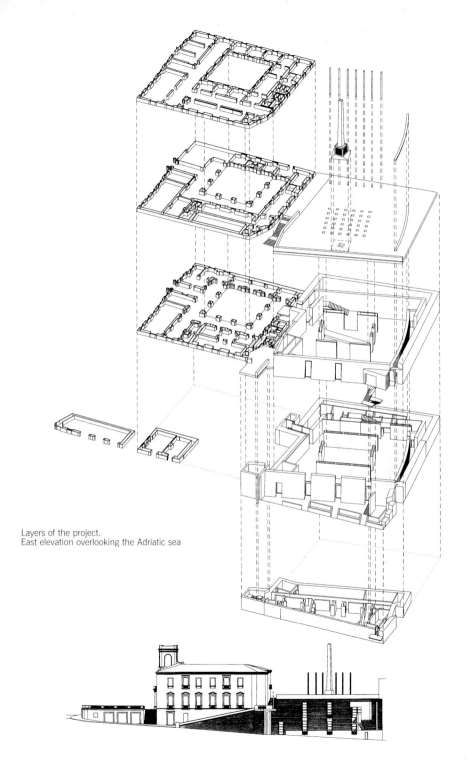

Layers of the project.
East elevation overlooking the Adriatic sea

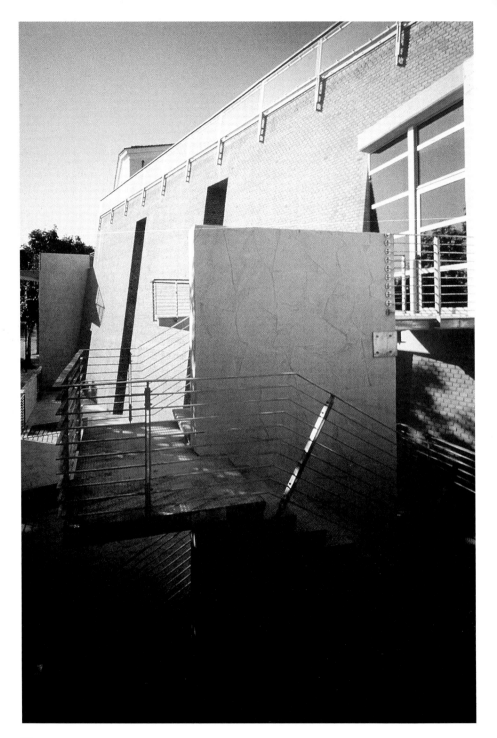

The excavated exhibition hall

East elevation

Centre for Contemporary Arts, Rome, 1999
(International Competition; Second phase project)

Mosè Ricci (capogruppo), Carmen Andriani, Aldo Aymonino, Pippo Ciorra,
Filippo Spaini; with Silvio D'Amore, Paolo Faraglia, Claudio Fioramanti, Mario Masci, Alberto Raimondi, Gabriele Mastrigli, Massimo Adario, Matteo Ive, Carla Ghezzi, Sonia Rizzo, Francesca Tata
Ministero del Patrimonio e delle Attività Culturali della Repubblica Italiana
1999 Second phase design

The proposal is based on two items. The first regards the character of gigantic, public containers which reclaims a dialogue with the city and the cultural district that is growing up around the Via Flaminia. The second item is about the idea of the display space and its internal organization, the various modes of circulation, the hierarchies that regulate the inner space of the museum in relationship to a particular site, and to a particular the time. The synthetic image of the museum comes out merging these two conceptual places, and materially is identified by the large glass skin that invites the

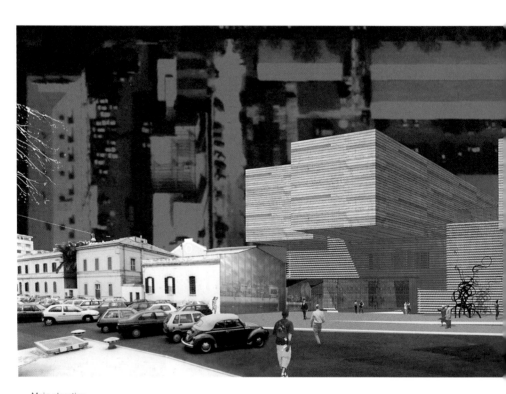

Main elevation

"city" of the museum, and by the big floating volumes of the galleries. The big glass atrium, connecting Via Reni and Via Masaccio, represent the urban image of the project. The quiet inner space of the display bodies simply let the arts happen inside.

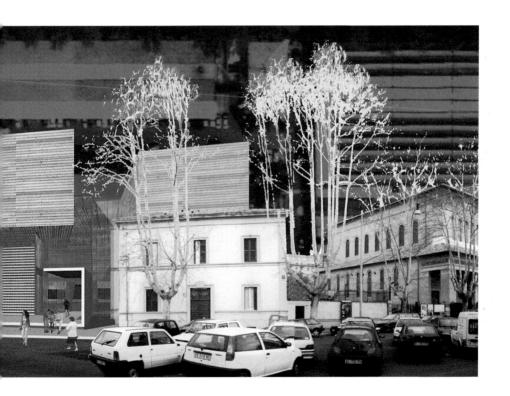

Renato Rizzi
Contemplation: The Appearance of the Immutable

Nihilism and metaphysics: the city in the gaze of thought
The dimension of the crisis afflicting the contemporary city requires the recognition of a truly radical cultural position. It means that it is no longer sufficient to reflect only upon the discipline of architecture in as much as it is an expressive language, but it is also necessary to rise up to a comprehensive rethinking of western thought in its entirety.
In fact the contemporary civilization is characterized by the predominance of technical-scientific knowledge and by the globalization that it assumes in facing up to the world. It derives from the "agnostic-nihilistic" condition that is caused principally by the formal dissolution of the city, because it privileges action with respect to thought, production with respect to meaning.
For "nihilistic" thought form and above all the form of the city, appears as the dissolution and destruction of form itself, in which prevails "becoming", the idea of process and has for its reference the archetype of Chaos. In observing and reflecting on the crisis, what emerges forcefully is necessity, the condition of epistemological-metaphysical thought, which, in difference to nihilistic thought, places at its own foundations the idea of form as real and symbolic unity of the parts and takes as its archetypal reference Cosmos.
For the city the problem of form and its unity understood in the humanist horizon of the epistemological-metaphysical condition therefore expresses itself on the one hand in the refusal of the homologization and the fragmentation of the nihilistic undertaking and on the other liberating the figurative identities, manifesting in the singular form of their own meanings.
But epistemological-metaphysical knowledge is not that different from technical-scientific thought, because the first is the spring from which the second originates. One wants only to have recognized in the dominant thought of western civilization, that in the humanist matrix there still reside those values and meanings which, even if till now repressed, can not be denied. Perhaps only with this awareness can the city pass from the "pragmatic wellbeing of the *informe*" to the "cultural wellbeing of form."

Form, New, Freedom
For some time now contemporary design culture has stopped reflecting on the idea of the form of the city, leaving to prevail its parts as disjointed and separate pieces.
The objective of the project is an attempt to replace in relationship, therefore in form, the specifics of the place with the generalities of the city, because it is considered that the whole has value: from the geographical territory to the most recent periphery. The problem of scale and its dimensional hierarchy does is not the only technical expediency to which it makes recourse, even if it implies rehabilitating the lost exercise of comprehensive vision.
It is necessary, rather, to open thought to a comparison with those terms that

today are presented as radical questions for the real city and to which the design will make reference: form, new, liberty.

Form
On the one side we have the urban shaplessness of the modern city that expresses itself by way of its three principal characteristics: dissolution, mixing and homologization. On the other side we have placed the historic form of the historic city which, instead, expresses itself by way of articulation, complexity, and stratification. The project searches for the meaning of form, and not that of the *informe*. A meaning of form that knows how to bring together and maintain the expressive differences that constitute both the quality of the historic city and the potential of the contemporary one.

New
The individual arbitrariness of languages has broken the comparison with the theme of the origin. Memory is part only of the record even if it becomes useless when one must think of the actual and the necessary. The new according to Manfredo Tafuri, must instead assume specific connotations: "it is called to develop as much as is contained in the moment of genesis, towards that origin that has in itself its own perfection." Between the origin and the new the fine thread of continuity is instituted, "because the vitality of the city is demonstrated in/by works that characterize the unequivocal *imago urbis*." But until that happens one needs to penetrate as much as possible into the depths of the origin, to then, and with equal force, distance oneself from it.

Freedom
The freedom of the new is a design bind. In fact, the bond is not a loss of strength but a taking of possession. Furthermore what renders insecure and confused is truly the absence of figurative and aesthetic limits (substituted by those normative/prescriptive) and it is that which actually determines the contemporary city. For these reasons the project takes on and works on the representative richness of the iconographic patrimony of the city, intended as the necessary foundation of the new aesthetic program.
The form reflects the meaning, therefore addresses the theme of representation. The theme of the new reflects the origin, therefore introduces the theme of continuity. The theme of freedom reflects the aesthetic-figurative limits, therefore reopens the theme of belonging.

Image: The protective veil of the city
Within the contemporary city modernity manifests itself as the absence of secondary values, therefore the absence of representation, the absence of the aesthetic dimensions. There does not exist an architecture, especially and urban architecture, that invests in form the aim of a renewed ontological-metaphysical meaning. In effect, contradicting all the false declarations, the city does not think architecture and similarly architecture does not think the city. In the city architecture must fertilize and react with the abstract social-economic program rather that submit itself to reflect metaphysical or

transcendent ideas: an idea not beyond the mundane but contained "within" reality itself. This particular way of reflecting as much is possible strives for closeness to the intimate meaning of things, therefore the hidden and profound essence of their nature to carry it to the surface, being that part visible to us.

In Greek thought the symbolic image of the city was represented by the goddess Tyche, Fortuna with the corona on her head. The goddess possessed an ulterior meaning: Virtue. The city therefore, not only depended on the good fortune, but also on its virtue; it aspired to both.

A city without reference to the image is a city without protection, at the mercy of pure becoming, of events and of the case. The infinite and futile personal non-images of the city's consumers, with their goal of the exclusive advantage of their own interests, have substituted the original image of the city. If we by the city we mean an entity greater than the sum of the parts that constitute it, then it is equally necessary to think of it in terms of the possibility of its comprehensive identity that implies the importance of the form that can represent it, therefore above all the importance of the images capable of in-forming it.

To understand the value of the image in an epoch that has rendered it useless and meaningless, requires a rethinking of the role it occupied both in myths and in history.

The first works of art had the task of producing effigies, shielding images to protect the world from the terror of the unknown, to defend it from the destructive power of the punishments wrought by the gods. The work of art was not even destined for the eyes of man. It was a gaze turned towards the invisible, because no living being could look at it. They were buried in the tombs and consigned to the dead. They were literally sacrificed.

Representation of the classical world, instead, happened within the Aristotelian trinity of idea-image-thing. The image constitutes the bridge between the abstraction of the idea and the formality of the thing over which their relationship must pass, defining thus the metaphysical place where the aesthetic experience is founded, then understood as consciousness and knowledge. In this tradition beauty is the coincidence of form and content. It is in fact perfection.

Modernity has further reduced the circularity of classical values, preferring a direct linear relationship, establishing a binary equation between idea and thing. The image is no longer called, invoked as mediator between ideality and reality. It is expelled because its presence impedes the process of acceleration, of increasing speed to which the technical has subjected the world. The aesthetic of the modern, untied definitely the un-dissolvable triad of beauty-goodness-truth, expressing a positivistic thought of the analytical-disjunctive type, investigates problems of classifying order, work that continues separations and removes itself from reality to flow into the exclusive domain of the pragmatic, of pleasure and entertainment. Art, architecture are no longer concerned with representing the world, but all the more describe the daily. Today we believe that we can look directly at the world, are able to dominate it. But we do not realize that it is literally petrifying us.

To resist its tentacular terribleness, this being our reflex, one needs to make recourse anew to the teachings of myths. Perseus saved himself from Medusa thanks to his intelligence, to his capacity to exercise an indirect look. It is only by way of indirect vision, the image reflected in the shield, that permitted the hero to lop off the snake ridden head of the Gorgone in a single blow. Between Perseus and the monster there, in fact, interposed the shielding image, the protective veil.

The refusal of the direct vision means then to exercise an aesthetic look capable of recuperating the originating quality of seeing, its theory, in the sense of supreme vision, of contemplation. A push towards the beyond, towards the incommensurable mystery hidden and conserved within the self of the thing.

But there is a further meaning that one must attribute to the image. In the German language its concept is translated with the word *Bild*, from which is derived *Bildung*: education, formation.

The image is the bearer of consciousness, of knowledge. A look that contemplates educates.

The image must return to be in the between, to occupy the space between idea and the thing, between the intelligible and the material, to protect us, like Perseus' shield, from the monsters that we have created, from the chaos of that which does not have form. But the image subsists as the aspiration to beauty, the beauty of that which is eternally immutable and necessary.

Today it is more necessary than ever to rethink the city in terms of its own images, in as much as only these permit to rethink meaning, even if only in the smallest part, to then transport it into concrete form. A theoretical necessity that, at least initially, runs parallel with the consolidated urban planning, with the aim of permitting an indispensable aesthetic preparation, and therefore ethical, for the difficult themes that involve the form of the city, for now almost completely absent.

Project for the Central Area of Corso Rosmini, Rovereto

Renato Rizzi
with Barbara Borgini
and Fabio Campolongo, Mateo de Cardenas
1998

The public administration committed to the revision of the new town plan invited a series of design consultants to examine eight area of the city.

For the area of Corso Rosmini the program required a particular attention be given to the urban centrality that holds it, with the aim of the piazzas being able to accommodate a reasonable number of underground car parks as well as the usual cultural and social activities.

Even if the place is the geometric center of the city, it nonetheless has the character of an internal periphery. In fact here one encounters the threshold between the historic model and the contemporary or better still here the conflict between the two is manifest: between the stratification of urban fabrics and the dispersal of buildings, between history and now, between the concept of place and that of space.

The design assumes, therefore, the elements of the "conflict" to transfigure them in an architectonic representation. The gardens, the changes in level, the borders, inclined planes, become some of the themes that certainly constitute the figurative language, with the aim of making a well designed landscape emerge from this "central periphery"; a new horizon from which many vistas of the city and its future panoramas can be observed. A place where perhaps one can begin a new to "contemplate."

View of the model

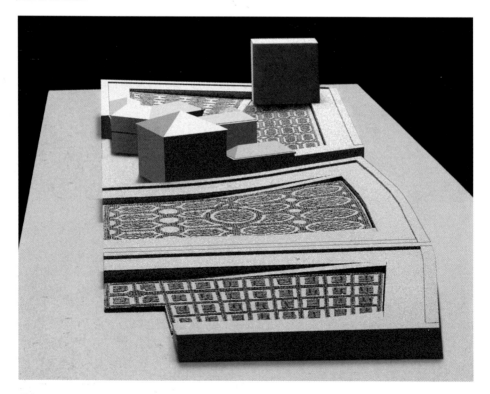

View of the model

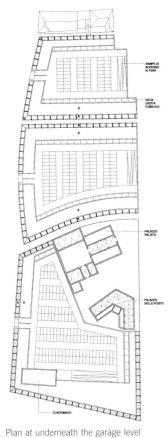

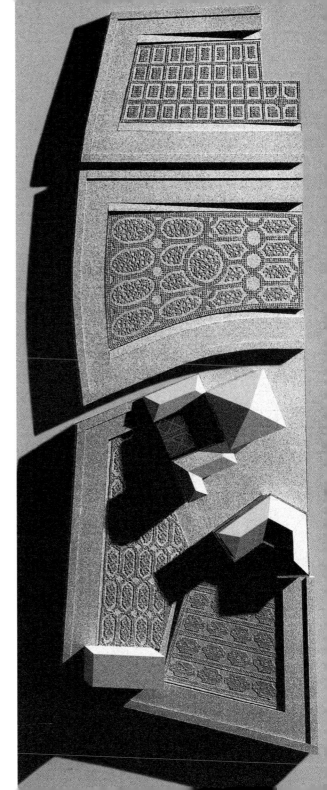

RAMPE DI
ACCESSO
AI PIANI

VIE DI
USCITA
PUBBLICO

PALAZZO
BALISTA

PALAZZO
DELLE POSTE

CONDOMINIO

Plan at underneath the garage level

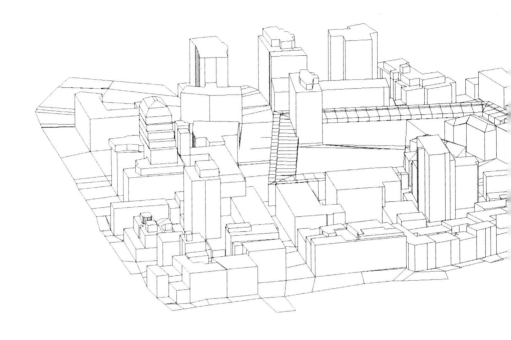

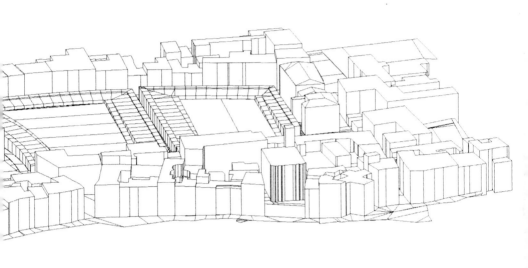

Urban Form, Rovereto

Thesis project. Students:
Gianfranco Consolini, Graziano Peterlini
1998-1999

The design hypothesis reflects the question on a crucial question for the city: the "form." Better still, one can think of a possible form for the contemporary city that is not pulverize nor dissolve that dominates today? The work is aimed at a positive even if provisional response.

In this case the city is seen comprehensively within its internal landscape (natural and historic) and within its different scales, from that of the territory to the architectonic by means of a theoretical-critical vision able to supersede the social-technical-scientific reductionism and relativism on which urban action is based today. The problem of form emerges as that real and concrete place where the city can elaborate, measure and manifest its own awareness of itself. The city is not only asked to reflect upon its practical meanings but it is also to investigate its ontological meanings which are its permanent principals therefore to rethink anew its identity of what is truly essential. A few indispensable concepts of the project are determined by these presuppositions: the idea in as much as it represents the singularity of the figure; the figure in as much as it is that which gathers in the image of the idea; meaning intended as expressive character of the figure.

 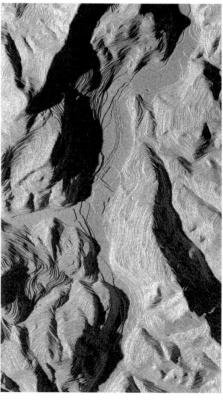

View of the model

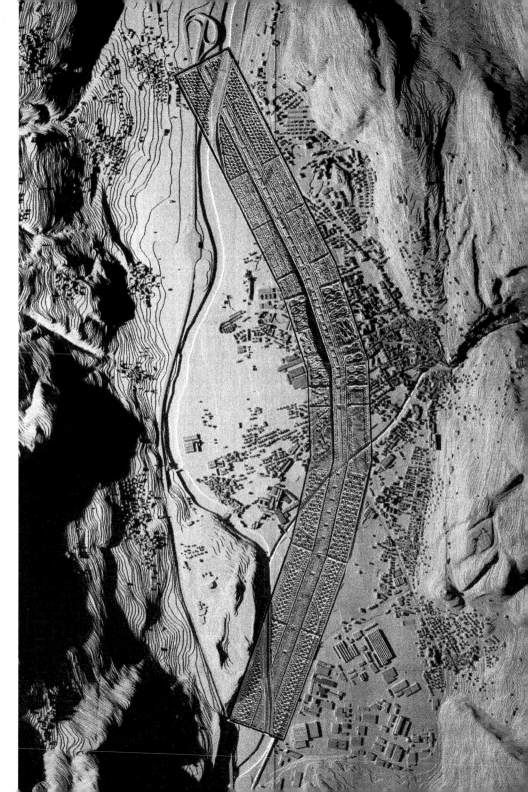

Area of the Former Montecatini Industrial Complex

Renato Rizzi
with Achille Gennari, Mateo de Cardenas,
Paola Moschini
1999

The Province of Trento promised a national competition for the recuperation of the area of the former Montecatini industrial complex. To the south of Rovereto, on the western slopes of the Vallagarina, a gigantic architecture from the beginning of the twentieth century, built for the production of aluminum, that appears in a state of waiting, balancing between nature-art-necessity.

The design program avails itself to: redeeming the value of the landscape by way the territorial scale; reinforce the threefold character of the architecture of the place: *aulico* (technical-nature), *tragic* (technical-art), *Dionysiac* (technical-necessity); rethink nature, history and the contemporary within the mythological-symbolic idea, subtracting them from the poverty of positivistic reductionism.

The project proposes a figurative structure that crosses over the valley at that point, generated by the principal body of the building, it suggests a new formal parameter for the valley and the view of it.

The whole of the proposed, in terms also of functional demands, is articulated into three ambits: the head, that foresees the philological restoration of the existing industrial buildings; the terrace of the three bridges, figure of connection between the existing and the new figure of the park. It passes over the river, but stops when it meets the motorway and the railway; the true and proper "park" figuratively (and functionally) connects the opposite side of the valley.

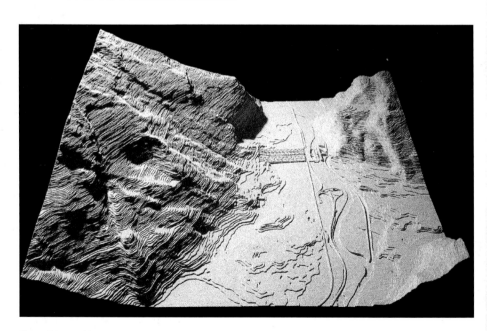

Views of the model

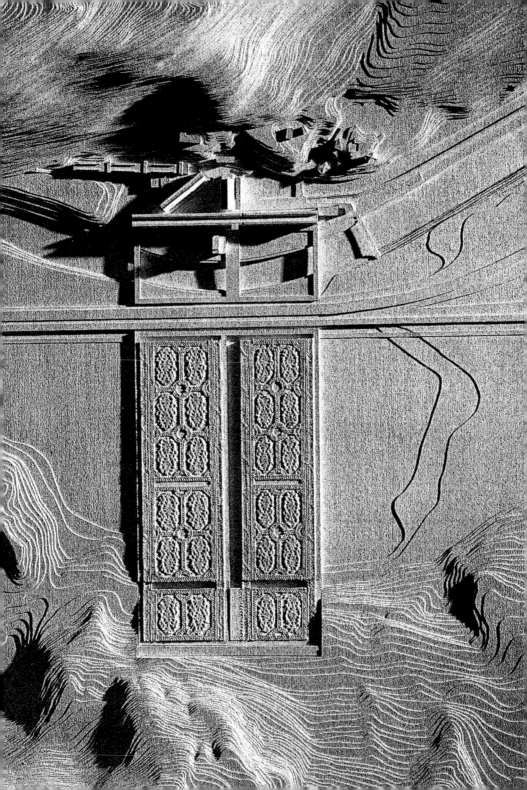

Zardini & Meyer
The Picturesque City

Today, in order to regain its true effectiveness, architecture has to turn for its materials to the rejects of the contemporary city and to the spaces left open by other disciplines.

It has to invent new *strategies* of intervention, less and less bound up with the production of objects and more and more with the production of *architectural effects*.

The instruments with which it must operate are the remains, the fragments, the ruins of the intellectual output of modern architecture, along with concepts and strategies developed in other disciplines. It is an *architecture of plunder*.

Consequently, the works of architecture produced are *indefinite*. They do not have the precision of the new, but the imprecision that comes from reutilization, from the montage of ideas, types, images and fragments of reality that already exist, but which we have lost all capacity to understand. They are also approximate because they do not set out to redefine reality completely, but only to introduce elements of change, to trigger processes.

They are banal interventions, which treat being *ordinary* as a quality. They tend to put on disguises, to conceal themselves: a strategy of survival. At the same time this strategy provides an opportunity to insert *viruses*, to contaminate *reality*, to carry out *genetic manipulation* of the various elements, modifying them, transforming, correcting, dismantling and reassembling them.

The underlying aim of all these efforts is to lay bare a reality that still eludes us, to find a point of *friction* with this reality. For this reason the field of action for these strategies is the *contemporary city*.

The contemporary city is an aggregate filled with tensions, and with forces. It is characterized by the simultaneous presence of elements or pieces that place an emphasis on their *individuality*, their *singularity*.

Up until now we have regarded *heterogeneity*, the apparent chaos of the modern city, as one of its negative aspects. But the fact is that heterogeneity is one of its qualities, and one which presents new possibilities for intervention.

Today, the concept of *picturesque* can once again be applied to our sensibility, a sensibility based on contrast and tension, on fragmentation and discontinuity, and no longer on an idea of overall harmony: this different sensibility allows us to comprehend and manipulate the landscape produced by the contemporary city.

By picturesque is not just meant something lively and colorful, agreeably untidy and irregular, but rather an attitude that leads us to treat what we have hitherto regarded as negative aspects of the contemporary city as positive values. Heterogeneity, irregularity, the unusual, the intricate, variety, discord, the incongruous combination of different pieces, the fragment, dispersion, indefiniteness, raw material, tactile values: all these become qualities of the picturesque.

The picturesque is inclusive, it takes in all the surroundings. It breaks down

the traditional distinction between *natural* and *artificial*. It accepts *individual* expression. It emphasizes the different *characters* of elements.

Yet it is no longer the single element, the single building, that attracts our attention, but the whole set of relationships, and of layers, that links the different elements together. They become tangled, causing interference and overlap and favoring *distortion* and *ambiguity* over precise relationships. *Approximation* rather than precision, *blurring* rather than clarity, *out of focus* rather than in focus: these are the qualities and characteristics of this new landscape.

Even the concept of space, which is used to express the physical relationships between different elements, becomes inadequate. In fact the qualities suggested by the term space are wholly abstract, very different from the realistic connotations that are immediately brought to mind by the term *landscape*, for instance, which more effectively conveys the idea of a complex set of relationships, of the simultaneous and overlapping presence of different systems. It also stresses the idea of mixture and is better suited to grasping the hybrid character of the contemporary metropolis.

Replacing the concept of space by that of landscape does not entail a change of dimension in the interpretation of phenomena, but a qualitative one: it underlines the presence of specific and concrete characteristics. The physical dimension, the scale of the interventions does not constitute the decisive factor: interventions are to be judged on the basis of the effects they produce, and there is no longer any direct connection between dimension and effect. The concept of *intensity* takes the place of that of dimension.

The concept of the void, or of empty space, also proves wholly inadequate: rather we need to speak of *interstices*, i.e. of gaps or intervals, between buildings. And a building, in turn, can be defined as an *interval*, an *interstice* between two other *interstices*.

The term *interstice*, like that of landscape, does not refer to scale. It indicates a new set of relations between buildings. In addition, it proposes a different relationship between *outdoor landscape* and *indoor landscape*, a relationship in which the boundary, the distinction between the two is blurred.

The picturesque makes its way into our homes as well: in fact heterogeneity, contrast and tension are now part of our mode of being.

Accepting the heterogeneity of the contemporary city is not simply an aesthetic matter, but a *political*, *social* and *ethnic* one. It is not a question of using a bogus variety to mask or exorcise a reality that is conceived as increasingly uniform, homogeneous and under control, or of concealing an ever stronger and more pervasive hidden order under an apparent disorder and visual anarchy. Rather it entails recognizing, accepting and giving voice to the different *individualities* present in society and in the contemporary city, in such a way that their simultaneous presence constitutes a richer and more varied political, social and physical landscape, based on *comparison* and not on mutual exclusion.

Landscape. Bus-City 1995.
The reclamation of some abandoned
quarries to the east of Milan, the
transformation of the agricultural and
industrial landscape through the
introduction of new activities and
inhabitants, the proposal of new
characteristics for the contemporary
way of living.

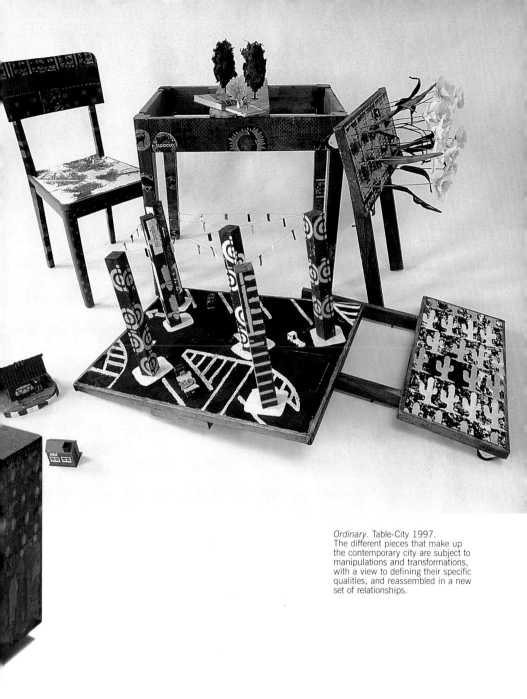

Ordinary. Table-City 1997.
The different pieces that make up
the contemporary city are subject to
manipulations and transformations,
with a view to defining their specific
qualities, and reassembled in a new
set of relationships.

Home. Enlargement of a house
1995.
The changes in ways of living, the
new relations between home and
work and the new conflicts that they
generate and that make their way
into our homes: does domestic
space still exist?

Natural. Lawn-City 1997.
A new landscape formed out of the mixture of natural and artificial elements: trees, lawns, flowers produced artificially on the one hand; objects produced "naturally" on the other.

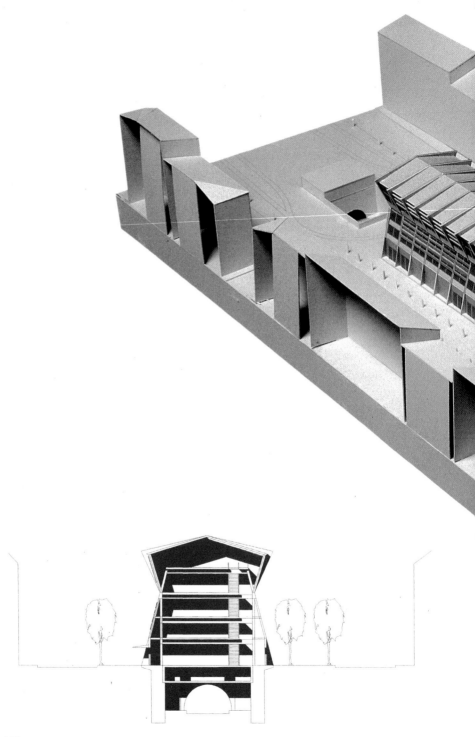

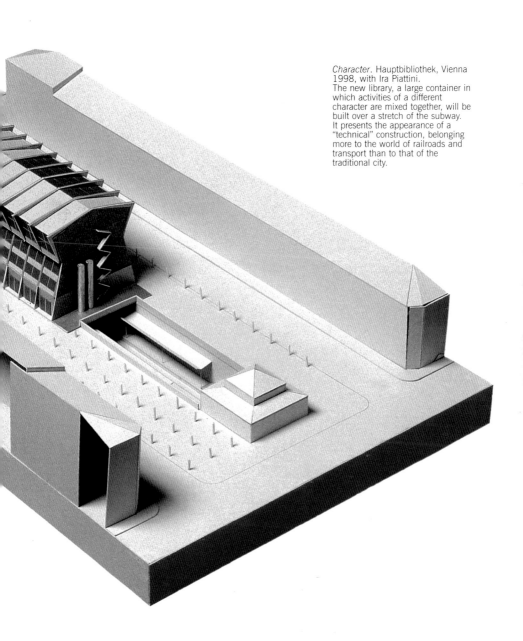

Character. Hauptbibliothek, Vienna 1998, with Ira Piattini.
The new library, a large container in which activities of a different character are mixed together, will be built over a stretch of the subway. It presents the appearance of a "technical" construction, belonging more to the world of railroads and transport than to that of the traditional city.

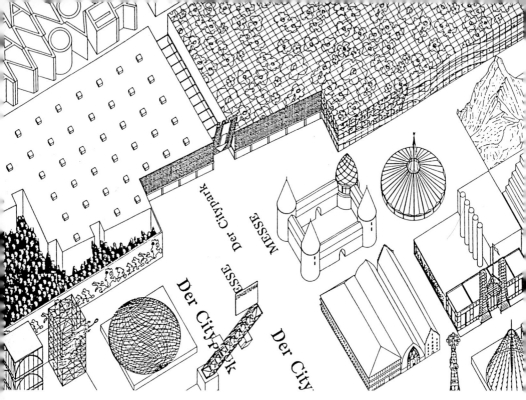

Within the illustration:
Der CityPark
MESSE
MESSE
Der City
Der City...

Individuality. Expo 2000, Hanover 1992.
In this new micro-city, dedicated to entertainment, consumption and cultural events, each pavilion is given a specific individuality, with a character all of its own.

Interval. Housing and service complex, Brescia-Fiumicello 1993. Raising the quality of the suburbs through acceptance and transformation of its elements, creating a new system of relations between empty and built space. The open spaces are given back their function, along with activities and a name.

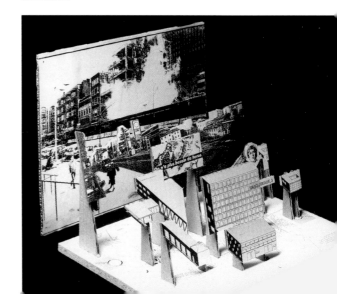

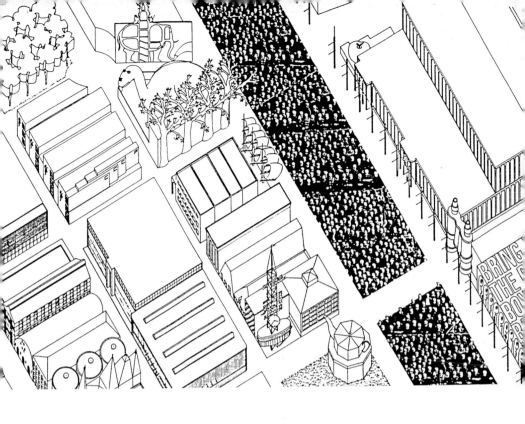

ORTI ALBERI UFFICI ABITAZIONI CINEMA NEGOZI
PALESTRA LABORATORI

Picturesque. Trailer-City 1999.
The new qualities of the
contemporary city: heterogeneity,
the unusual, the intricate, variety,
discord, the combination of different
pieces, the fragment, dispersion, raw
material: a new idea of the
picturesque.

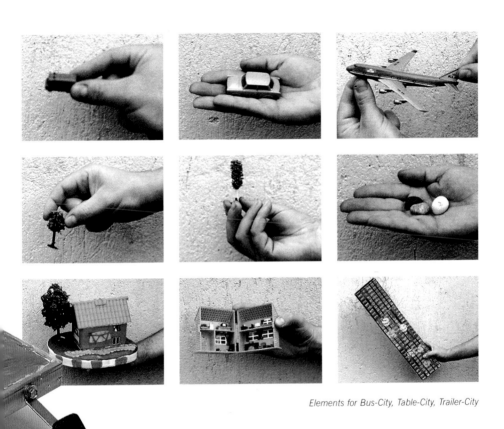

Elements for Bus-City, Table-City, Trailer-City

Cino Zucchi
"A city is not a tree": New Models of Urban Space

"A city is not a tree": the ambiguous meaning of the title of an article written by Cristopher Alexander in 1965 is enlighted by its content[1]. Alexander criticizes the abstract, tree-like scheme which governed the urban planning theory of those years; a scheme in which each part interacts with the whole via a pyramidal hierarchy, constituted by sub-groups which are connected in clusters to form larger and larger units. In opposition to the deterministic diagram of the "artificial" cities (the New towns, Brasilia, Chandigarh), Alexander argues that the "natural" city, the one sedimented in time, functions rather as a "semi-lattice", as an open structure, where parts are cross-connected by different orders of relationships and the smaller scale elements can interact among themselves without being ruled by the inflexible hierarchy of the zoning, by the distinction between main and local roads, by the "neighbourhood units", by the division between self-sufficient residential districts and a city center reduced to a dispenser of services. Alexander criticizes many of the axioms of contemporary planning: the separation between cars and pedestrians, the segregation of playgrounds in modern residential quarters, the collection of functions according only to typological similarity. The "semi-lattice" city would instead allow several informal connections, complex relations between different orders of magnitude, meaningful interferences among the parts. The opposition between the concepts of "tree" and "semi-lattice" reminds us of another opposition, the one between "dendromorphic" structure and "rhizome" structure, put forward by the obscure and narcissistic narration of Gille Deleuze and Félix Guattari in 1980, where, in *Mille plateaux* "the arborescent method is overturned. The tree, this symmetric and regulated system, founded on roots, does not work any more as a method of knowledge. Indetermination, probability, chaos, are the concepts on which sub-atomic physics is reshaping itself, but also the concepts which explain the cultural drift of our time. *Mille plateaux* proposes a method which is called rhizome [...] Principle of connection of the etherogeneous. Wasps and orchids, neurons and electrons make a rhizome. Principle of multiplicity [...] Principle of self-meaningful rupture [...] *Mille plateaux* does not have a center, but if we want to look for its center, it lays in the principle of de-territorialization. *Mille plateaux* is a book about de-territorialization."

As we employ bees and flowers to explain sex to small children, so many authors appear, in a positive or negative way, seduced by phitomorphic metaphors of knowledge: an animistic naturalism radiates from many attempts to put order into the territorial explosion of this century. The *tree* and the *network* seem to compete with each other as conceptual models of the structure of contemporary territory: on one side the regular and significant hierarchy of the elements, the historical stratification of larger and smaller centers, of city centers and outskirts, and the parallel modern attempts to control material flows, exchanges of information, figures. On the other side the icon of disorder but also of democracy, self-ruled flexibility, lack of center. Planning versus *lassaiz-faire*, history versus contemporaneity, harmony ver-

sus anarchy, beauty versus chaos. If the dilemma is often of an academic nature, the development of the European city and territory seems to take shape as a hybrid in constant evolution between those two models.

A new tight array of connections is overlayered on the ordered sequence of the old city, radically altering its meaning, changing the relations among the parts. We can see how the metropolitan underground, linking together unexpected points of the city with subterranean bypasses that ignore the historical connection routes between center and surroundings, produces a radical overdubbing in our experience of city users, subverting or reinforcing old position values. In the territory, the atopic settling tendency of shopping and entertainment centers generates a new network which interferes in complex ways with the old nuclei, with the deep structure of historic man-made landscape. In the Venice area, driving along the banks of the Brenta river, the glimpse of a Palladian villa alternates with the one of a shoe factory outlet, a row of old poplar trees is followed the light-poles of a large parking lot.

Unexpectedly, the ways of living and the etiquette of the historical environment and of the extended city influence each other: new spaces are used following traditional, almost village-like customs; on the other side we project on the old city many functional and formal expectations derived from the "transitivity" of the new lifestyles.

But the aphorism-title of Cristopher Alexander's essay reminds us of another founding condition of the design act, which we can today set forth in explicit antithesis to the dangerous contamination between neo-technical optimism and alleged cosmic harmonies represented by the New Age philosophy: the condition of fallibility implicit in any process of knowledge. Karl Marx made a famous distinction between the work of the bee and the one of the architect; in the same way, the beauty of the tree cannot be the same beauty of the city, as, for Paul Valéry, the one of the seashell is not the one of a man-made object. The separation between thought and work generates a hiatus, a degree of freedom between idea and artifact, which is filled in by the process of reciprocal deformation that thought and matter undergo in the design act: "This is an absolute condition: if a thing cannot be made but in a unique way, it its like this very thing is shaping itself; and therefore this action is not really human (since thought is not necessary) and we don't understand it [...] We begin our works starting from different sorts of freedoms: freedom, more or less extended, of matter; freedom of figure, freedom of duration, all things which are forbidden to the shell animal, a being that knows nothing but its lesson, with which its own existence almost coincides."[2]

The beauty of the city is multiple, fallacious, occasional; but when it occurs, it overcomes the one of nature, it conforts us in its absence of perfection. Its lack of necessity makes it dear, precious, moving. Our city is not a tree, and for this reason we can understand it. The city protects us from the merciless inexplicability of nature, from the cruelty of its behaviors—dying between predator jaws is surely not our ideal of comfort—from the moral violence of its good example.

[1] C. Alexander, "A City is not a Tree", in The Architectural Forum, april-may 1965.

[2] P. Valéry, "L'homme et la coquille", in Nouvelle Revue Française, February 1st, 1937, now in idem, Œuvres, Pleiade, Gallimard, Paris 1957, pp. 895-900.

1995
Closed Competition for the Refurbishing of the Dismissed Junghans Industrial Complex on the Giudecca Island and for the Construction of New Housing Units, Venice (first prize)

Cino Zucchi, Paolo Citterio, Alessandra Dalloli, Stefano Guidarini, Pietro Nicolini, Marco di Nunzio, Federico Tranfa with Marco Beretta, Sarah Bolzoni, Andrea Marlia, Anna Chiara Morandi, Delphine Plojoux, Stefano Vaghi

The urban scheme tries to embody the ambivalence that appears to animate in Venice the relationship between buildings and landscape: on one side the recurrence of dimensions, of details, of typological solutions which form altogether the uniqueness of the urban fabric of Venice; on the other side, the continuous blurring of the monuments into the landscape, in that incredible artificial setting of the Laguna. The ex-Junghans enclave is opened up and reshaped in continuity with the north-south direction of the Giudecca fabric, creating a new square overlooking the Laguna near the existing school garden on the east of the area.

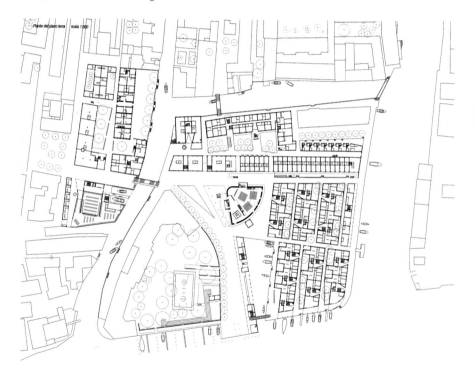

Ground floor plan

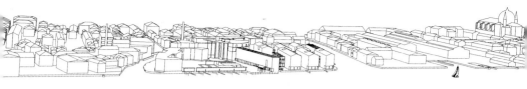

Perspective view

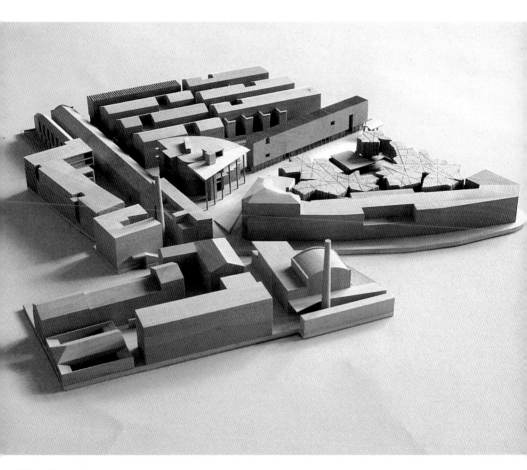

View of the model

1998-99

Final Design of the A2-A3, B, D, E1 Buildings of the Urban Renewal Plan for the ex-Junghans Area, Venice

A2-A3 Building: Cino Zucchi, Pietro Nicolini with Cristina Margarini, Carlotta Garretti, Stefano Vaghi
B Building: Cino Zucchi, Alessandro Acerbi, Federico Tranfa with Caroline King
D Building: Cino Zucchi, Alessandro Acerbi, Anna Chiara Morandi, Ida Origgi, Franco Tagliabue, Federico Tranfa, Luca Zaniboni with Natasha Heil, Gaudia Lucchini
E1 Building: Cino Zucchi, Alessandro Acerbi, Federico Tranfa, Ida Origgi

The A2-A3 building is a simple existing industrial building. Small alterations in its profile try to give architectural dignity to its new role as a backdrop of the newly designed square. The loggias excavated in the topmost floor underline the screen-like character of the south facade, whose new public function is reinforced by a new copper-cladded canopy.

The B building constitutes the integral reconstruction of a small existing body overlooking the canal. The new thin brick slab follows the profile of the pre-existing building through a deflection in plan and section. Large double-height loggias overlook the green Campiello.

The D building is the substitution of an existing building at the junction between two canals. Its cubical volume recalls closely the one of the Venetian waterfront palaces, reproposed in an "abstract" form through the emphasis on the planarity of its surfaces. While the materials are very traditional (gray sand plaster, white Istria stone, white stucco for the trapeze court), small hints reveal the impossibility of an historicist replica.

The E1 building flanks the new piazza and the new canal ditched in the south-east quadrant of the area. The front toward the piazza is constituted by a screen of stone slabs of different colors and textures. The water side, more simple, is pierced on the ground floor by portals which increase its visual permeability.

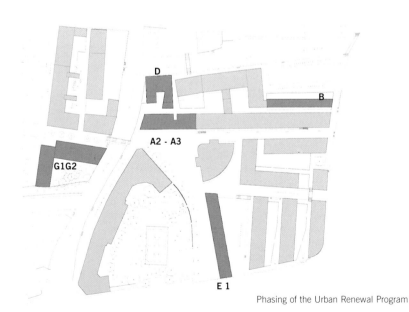

D

B

A2 - A3

G1G2

E 1

Phasing of the Urban Renewal Program

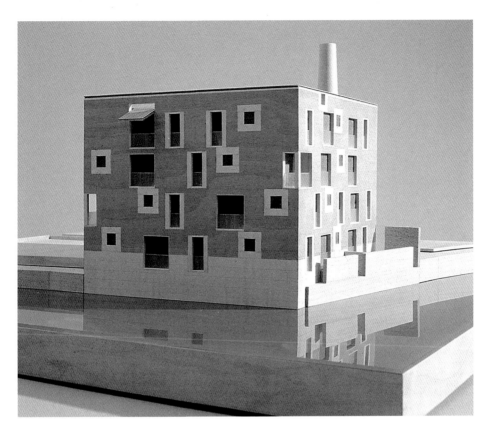

Building D, view of the model

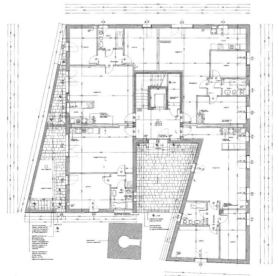

Building D, first floor plan

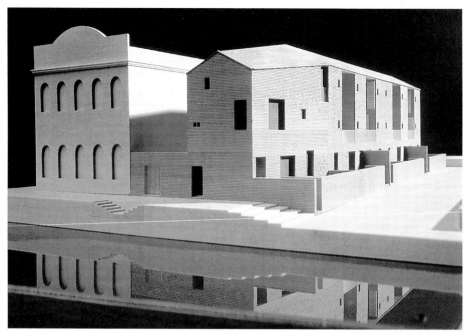

Building B, view of the model

Building E1, perspective view

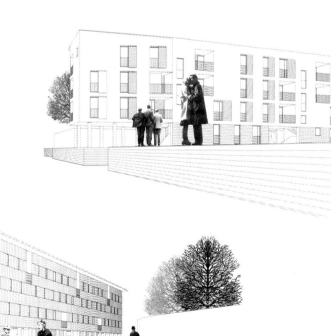

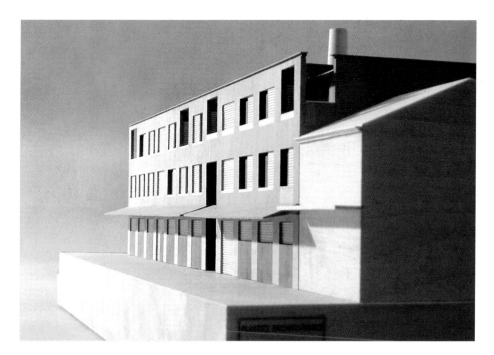

Building A2-A3, view of the model

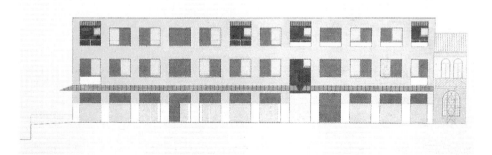

Building A2-A3, elevation

1994-96
Single-family House, Abbiategrasso (Milan)

Cino Zucchi, Andrea Viganò, Anna Chiara Morandi

A narrow plot in a rather common suburban situation constitutes the occasion for a reflection on the relationship between domesticity and open space. A large "rural" copper-cladded portico nearly touches a heavy brick slab, determining a collective space immersed in the green. Neither pavilion nor patio house, the building explores the degrees of freedom of the theme of the suburban house in the morphology of the Italian peripheries.

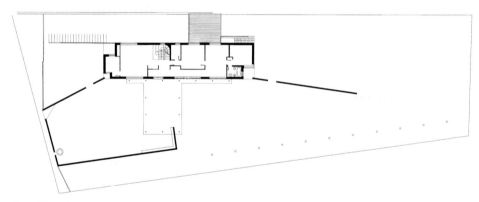

Ground floor plan

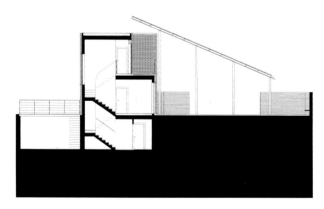

Cross section

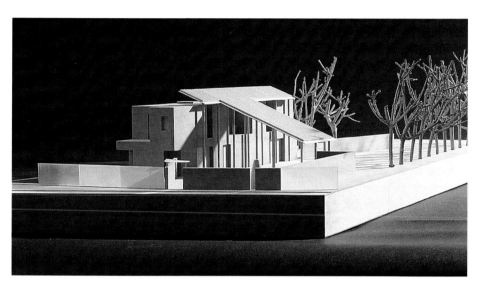

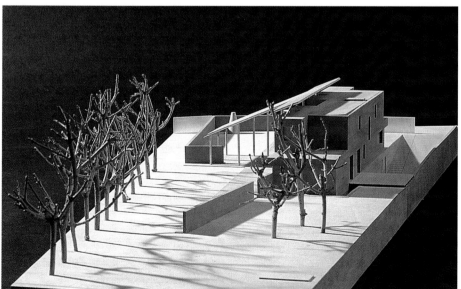

Views of the model

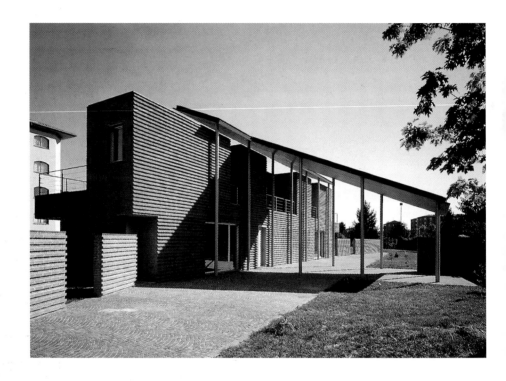

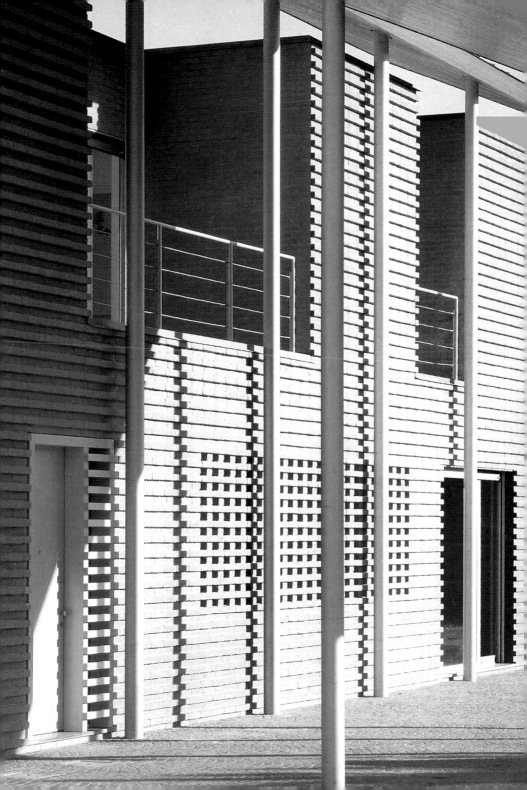

Some Urban Legends

Photography is a problem in 1999. A virtuosity that we cannot afford. The rapidity with which our daily scene is changing would suggest new and faster systems of reception, translation and transmission of the present. We are increasingly aware of a need for less elaborate and more immediate images so as to translate the new signs of the landscape into real time. Fiber-optic cables, digital videos and electronic mail have changed our way of thinking about real images.

End of the millennium urbanism requires end of the century video cultures. We are using kinetic and mutating imagery more often and more successfully in order to obtain greater *fidelity* of the events instead of photographic aesthetics. In brief, as it happened with photography in the last century, we now have need of another code to decipher the new characteristics producing the change in the social landscape. The question is therefore: what meaning do photographs have today?

The new united Europe has three extremities, three cardinal points marking its farthermost points: Capo Spartivento in Italy to the South, Capo da Roca in Portugal to the West, and Grenen in Denmark to the North. Whoever reaches them discovers that they are different since they are real terminuses and not just places of transit; they are outposts in the nothingness, coastal lookouts. But, above all, they are places without signs of any kind: there is no writing on the walls or refreshment signs, no neon signs or vending machines, no motel signs or special offers. There is nothing. In our mobile civilization, places have more and more often become reduced to crossings, while spaces have become mere collectors of signs and signals indicating the street to whoever passes by. However, in these three places which cannot be crossed for the streets terminate in the open sea, no one transits, no one observes, and almost nothing changes. They are places without directions, ignored by the forces evolving in the urban and social space of Europe. They are three places where there never seems to be any change in meanings. In this outpost of civilization (or backwater according to one's point of view) we urban Boy Scouts would probably not know which images to fix. It is these places, however, that provide us with some clues about the many photographs of the urban landscape. Perhaps because the images that "emit meanings" today are more and more often the ones that can catch each new relief in the landscape, each signal that is to be added to the chaos of the present day signs. While it is true that it is no longer possible to keep the warehouse of materials accumulated from humanity in order, it is also true that there is an increased need to check each new sign of change so as not to lose that sense of awareness that lets us participate in the physiological growth of cities.

The projects presented on these pages all share the special quality of being coherent. They are sensitive projects of architecture more concerned with being a connection than with being a reference to the contexts in which they are inserted. While these new projects of architecture communicate with the form of the current city, certain recent images visu-

alizes the complex landscape that supports and houses such examples of architecture. And if cities are architecture and communities, then video cultures are systems that can investigate the intricate relationships that bind stones to people. Many are the photographers who criss-cross the peninsula like rhabdomancers, following apparently unsystematic itineraries, surveying and tracing the potential new lines of development in a territory that is no longer comprehensible from a single point of view. And together these lines weave a web of facts, places and people: a terrain that supports the "visibility" of such projects. A myriad of minor events which when repeated in infinite images become new urban legends. We find these legends again in an impressive series of coincidental everyday scenes: the video clips on the music channels, the closed circuit telecameras in supermarkets, the urban simulations of H 3D video games, local news broadcasts, and the video vigilance on the Internet.

Because they are more spontaneous, reliable, and imminent, these images are preferable to *cultured photography.*

So why do we continue to describe the forms of places and tell stories about certain inhabitants using an apparently dead language, or better yet an out-of-date one? Why communicate with the Morse Code in the era of the Internet? Why persist in supporting photography in the age of contingent reproducibility? Because photography has the power to fix things. The chemistry fixes a place in a given way and in a given moment, after which nothing can be done to deny that objective verity. This is why photographs and their negatives are accepted as evidence in American courts, no other forms of recording reality are, only photographs. Photographs continue to have the validity of documents. And there is one more thing. The fixity of photographs forces us to make comparisons. Stories projected on the screen slip away from it and our memories, no matter how innovative or dramatic they may be. On the other hand, photographs remain there, immobile, hanging from a nail or next to the shelf where we leave our keys, bags, and overcoats every day. At the most they turn yellow, but they do not go away nor do they change. They remain fixed where they are, staring at us, telling us that at a certain time things did or did not happen in a certain way. Every day, as we leave or return home, that reality is there for us to face. The insistence of the photographs and the looks they have knowingly produced justify the consideration that such a fixity is related to a new ethics of viewing places. An ethics of viewing that does not let any sign slip away from the Italian screens, no matter how insignificant, without leaving at least a slight trace of itself. And every day inside the frame we discover a sign or meaning that had escaped us. Because more or less intentionally photographs can see everywhere, even where there is apparently nothing; they find signals anywhere, even at North Cape. That photographs contain only meaningful landscapes is not so important after all. What is important is that they continue, even in the age of virtual and digital images, to be the same and force us to make comparisons with the things they contain.

Marina Ballo Charmet,
from *Con la coda dell'occhio*, 1993-1994

Marina Ballo Charmet,
from *Con la coda dell'occhio*, 1993-1994

Marina Ballo Charmet,
from *Con la coda dell'occhio*, 1993-1994

Marina Ballo Charmet,
from *Con la coda dell'occhio*, 1993-1994

Olivo Barbieri,
Benevento 1999

Olivo Barbieri,
Milano 1999

Antonio Biasiucci,
Napoli 1991

Antonio Biasiucci,
Napoli 1993

147

Antonio Biasiucci,
Solfatara 1995

Antonio Biasiucci,
Napoli 1996

Botto & Bruno,
A crack into the dream, 1999

Botto & Bruno,
Suoni di periferia, 1998

Botto & Bruno,
Suoni di periferia II, 1998

Botto & Bruno,
Ricordo di periferia, 1998

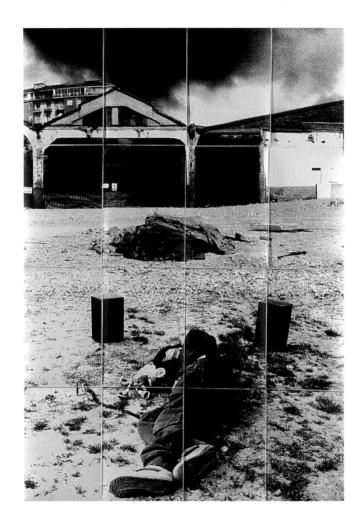

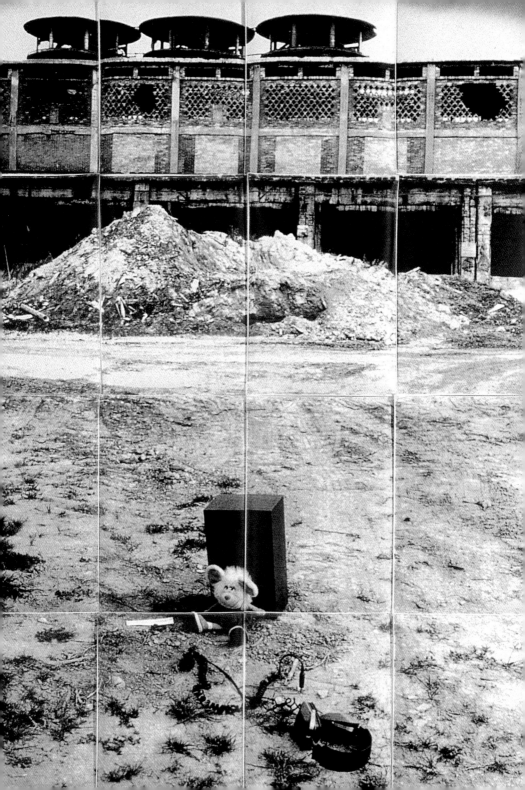

Vincenzo Castella,
Milano 1998,
from *Le città nomadi*
Courtesy Le Case d'Arte,
Milan

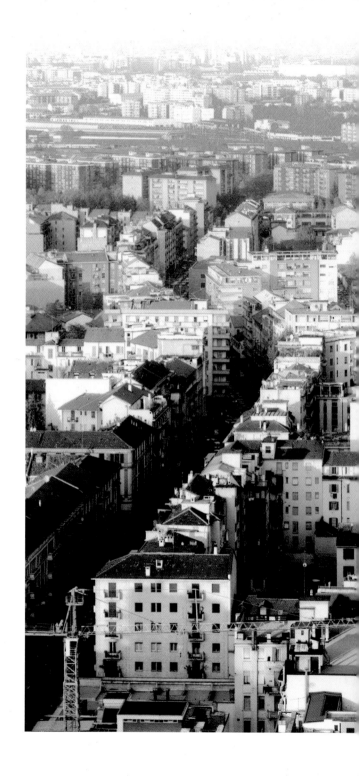

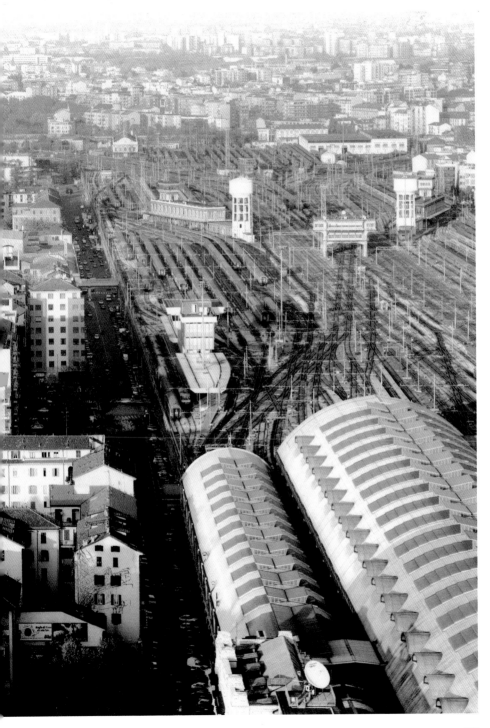

155

Vincenzo Castella,
Napoli, Splendid '98
from *Le città nomadi*
Courtesy Le Case d'Arte,
Milan

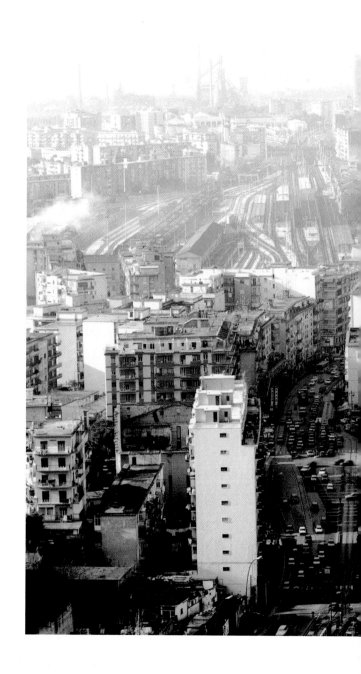

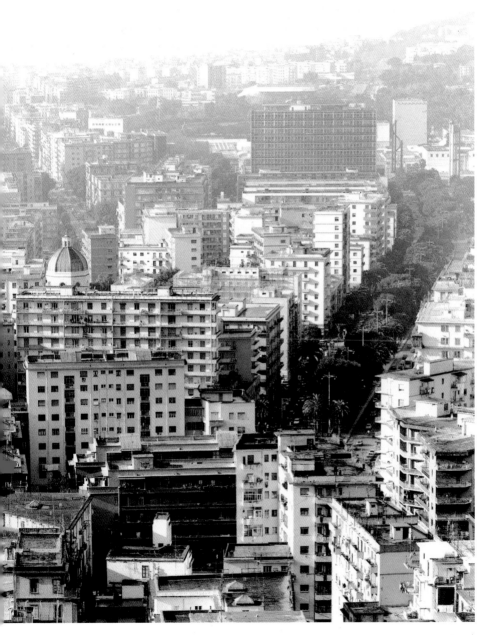

Marco Calò,
Audience
from *Dintorni dello sguardo*,
Naples, 1997

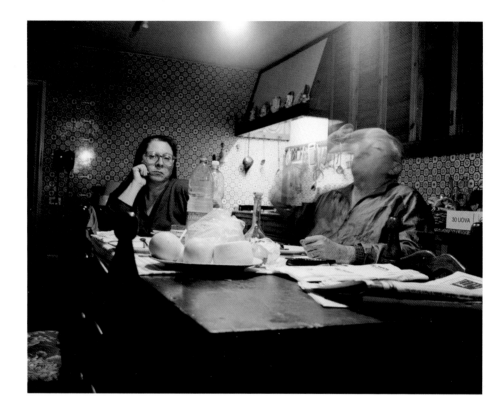

Marco Calò,
Audience
from *Dintorni dello sguardo*,
Naples, 1997

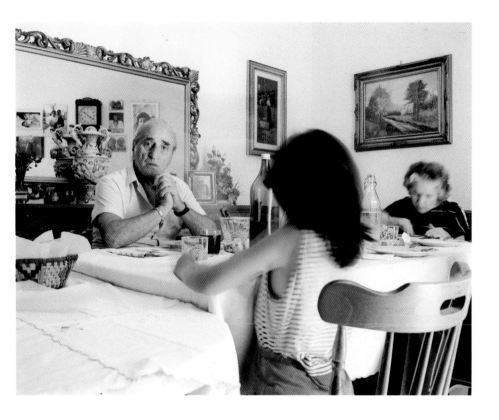

Marco Calò,
Audience
from *Dintorni dello sguardo*,
Naples, 1997

Marco Calò,
Audience
from *Dintorni dello sguardo*,
Naples, 1997

Alessandro Cimmino,
Porto
from *Dintorni dello sguardo*,
Naples, 1997

Alessandro Cimmino,
Via Giantorco
from *Dintorni dello sguardo*,
Naples, 1997

Alessandro Cimmino,
from *Dintorni dello sguardo*,
Naples, 1997

Alessandro Cimmino,
from *Dintorni dello sguardo*,
Naples, 1997

Paola De Pietri,
1995

Paola De Pietri,
1995

Paola Di Bello,
Concrete island, 1996-1999 / cot

Paola Di Bello,
Concrete island, 1996-1999 /
variable dimensions

Paola Di Bello,
Concrete island,
1996-1999 / dog's bed

Paola Di Bello,
Concrete island,
1996-1999 / couch

Francesco Jodice,
Cartoline dagli altri spazi,
Naples, 1996-1997

Francesco Jodice,
Cartoline dagli altri spazi,
Naples, 1996-1997

Francesco Jodice,
Cartoline dagli altri spazi,
Naples, 1996-1997

Biographies

ABDR

Maria Laura Arlotti, Michele Beccu, Paolo Desideri, and Filippo Raimondo have been carrying out their professional activity since 1982. The ABDR studio has participated in numerous architectural competitions, receiving awards and commendations, and the activity of its members has been documented in leading architectural reviews and in collective and monographic publications. The studio has exhibited its projects in Cologne, Aachen, Vienna, Toronto, Helsinki, at the D.A.M. in Frankfurt, and on numerous occasions in Italy. In 1995, it participated in the Milan Triennale "Il centro altrove", and in 1996, in the VI Biennale of Venice "Sensori del futuro". In 1997, the studio held its own exhibition at the AAM of Milan.

Maria Laura Arlotti carries out research in the Itaca Department of the University "La Sapienza" of Rome; Michele Beccu teaches at the School of Architecture of the Polytechnic of Bari; Paolo Desideri and Filippo Raimondo at the School of Architecture of Pescara.

Carmen Andriani

Born in Rome in 1953, she took her degree in 1980, and has had a studio in Rome since 1978. She is Associate Professor of Design at the School of Architecture of Pescara. She deals with modifications of the coastal landscape and the redesigning of abandoned areas. She has been Visiting Professor at Waterloo University in Toronto, and at the Syracuse University School of Architecture as well as guest critic at several American universities. She has received awards and recognition at international design competitions. Among these the following are of note: the international competition for the re-qualification of the Borghetto Flaminio (1995-1996 – first and second stages); the competition by invitation for the amplification of the Galleria Nazionale d'Arte Moderna in Rome (1996); the international competition for the new IUAV building in the area of the Magazzini Frigoriferi at San Basilio, Venice (1998 – first and second stages); the international competition by invitation for the new San Sisto Parish Complex in Perugia (1999). She designed the monumental tourist walk from Piazza del Pantheon to Fontana di Trevi (1992-1999). In 1995, she participated in the Triennale of Milan, and in 1996 in the International Exhibition of Architecture of the Venice Biennale. Since 1994 most of her research activity, in particular the redesigning of contemporary landscapes, has been carried out in collaboration with Giangiacomo d'Ardia.

Aldo Aymonino

Born in Rome in 1953, he graduated with honors in Composition at the University of Rome in 1980 with professor Ludovico Quaroni. He is presently Associate Professor of Composition at the School of Architecture of Pescara. He worked in the studio of Aldo Rossi (1977), and Carlo Aymonino (1981-1982). He collaborated with Franco Purini (1982-1983). Since 1982 he has been working on projects in Rome and Ravenna. Some of his didactic and design researches have appeared in leading Italian and foreign architectural journals: "Abitare", "Casabella", "Domus", "Lotus", "Modo d'A", "Bauen+Wohnen", "Bauwelt", "Der Architekt", "A+U", "Architectural Design", and "Architese". He has given lectures about his didactic, scientific and design researches at Italian and foreign universities: Milan, Rome, Naples, Perugia, Ascoli, Palermo, Venice, Vienna, Lubiana, Toronto, Lyon, Zurich and others. In 1989, he won the first prize "Architettura Italiana della Giovane Generazione". In 1991, he was invited to exhibit in the Italian pavilion of the Fifth International Exhibition of Architecture at the Biennale of Venice, and in 1995 in the exhibition "Il centro altrove" at the Triennale of Milan. Since 1992 he has been Visiting Professor at some North American universities, among which the Waterloo University School of Architecture, the University of Toronto School of Architecture, and Cornell University. He has been part of the Forum for the review "Lotus International" since 1997.

Marina Ballo Charmet

Marina Ballo Charmet was born in 1952 in Milan where she lives and works. After graduating in philosophy, she specialized in psychology, working in the field of child psychoanalysis. Since the mid-eighties her research has been in photography, and more recently in video installations. Some of her one-woman shows have been: in 1966, "Con la coda dell'occhio", Fondazione Mudima, Milan; in 1998, "Rumore di fondo", Musei Civici, Palazzo Gambalunga, Rimini; in 1999, Centre Nationale de la Photographie, Paris; Centre Regional de la Photographie, Nard Pas de Calais; Rocca Paolina, Perugia; "Anni '90. Esperienza", Fondazione Cerrente, Milan; "Cityscape", Galleria Monica De Cardenas, Milan; "La Matiére, l'ombre, la fiction", Galerie Colbert, Paris.

Olivo Barbieri

He was born in Carpi in 1954. Since the early Eighties his research has concentrated on artificial light. In 1990, he presented his research in a personal exhibition at the Rencontres Internationales in Arles. In 1991, he published his book *Notte*. In 1993, he took part in the exhibition "Muri di carta, Fotografia e

Paesaggio dopo le avanguardie" at the Biennale of Venice. In 1995, he published *Illuminazioni Artificiali*, a summary of his journeys to China, Japan and the West with a text by Enrico Ghezzi. In 1996, he had his first retrospective exhibition at the Folkwang Museum in Essen. He published *Olivo Barbieri seit 1978*. In 1997, he participated in the exhibition "Venezia-Marghera. Fotografia e trasformazioni nella città contemporanea" for the Biennale of Venice. Among his awards are the "Premio Friuli-Venezia Giulia Fotografia 1990" and the "Higashikawa-cho Award Japan 1992". His works are included in important international collections such as the Cabinet des Estampes de la Bibliothèque Nationale of Paris, the Folkwang Museum of Essen, the Museum of Modern Art of Beijing, the Fundación Joan Miró of Barcelona, New York University, and Palazzo Fortuny in Venice.

Antonio Biasiucci

Anthony Biasiucci was born in Dragoni (Caserta) in 1961. In 1980, he moved to Naples where he studied political science. His research was originally concerned with anthropological photography and the rural world of Campania. On moving to Naples he began to investigate the spaces of the urban peripheries. 1984 marked the beginning of his collaboration with the Vesuvius Observatory,

documenting the active volcanoes in Italy. In 1987 he met the stage actor and director, Antonio Neiwiller, with whom he worked until the death of the latter in 1993. In 1992, he won the "European Kodak Panorama" prize at Arles. From the earliest days of his photographic activity, his artistic research has investigated Italian cultural themes, particularly those of the South. In recent years, it has become a journey into the primary elements of existence and personal memory.

Stefano Boeri

Stefano Boeri was born in Milan in 1956. He teaches Design in Genoa and Milan. In 1999, he was Guest Professor at the Berlage Institute in Amsterdam. His research has explored the new condition of the European urban territories and the forms with which the different disciplines "look at" and represent the contemporary city. These subjects have been the basis for projects and installations (for the Biennale of Venice, the Triennale of Milan, the international exhibition of contemporary art "Dokumenta X" at Kassel); he has written articles and two books: *Il territorio che cambia*, 1993, and *Sezioni del paesaggio italiano*, 1997, *Cross Sections of a Country*, Scalo, 1998. He writes for the cultural section of the newspaper "Il Sole 24 Ore". His studio—the architects Giovanni La Varra and Gianandrea

Barreca joined it in June 1999—specializes in architectural and urban design. It has recently developed re-qualification projects for some coastal and port areas in Genoa, Naples, Trieste, Mitilene, and Venice. Two incubator plants are currently under construction for small firms at Sesto San Giovanni and a Geothermic Central of Enel at Bagnore in Tuscany. In 1999, he was invited by AIR (Architecture International Rotterdam) to draw up a landscape project for an island south of Rotterdam. He has participated in many design competitions both in Italy and abroad, among which that for the new Centre of Contemporary Art in Rome (admission to the final stage), the new municipal building in Seregno (second prize), the re-qualification of the layout of the Ferrovie Nord Milano (first prize), the new Fusina-Venice Tourist Terminal (third prize), and the new university college in Pavia (1993 European Prize).

Botto & Bruno

Gianfranco Botto and Roberta Bruno both live and work in Turin where he was born in 1963 and she in 1966. Their principal personal exhibitions: in 1992, at the Unione Culturale Franco Antonicelli in Turin; in 1994, at the Galleria Spazio Dinamico in Turin; in 1996, at the Galleria Alberto Peola in Turin; in 1997, "Gli stessi sogni" (with Sara Rossi) at the

Galleria Le Case d'Arte in Milan; at the Barbieri Studio in Venice; "Wall Paper" at Bullet Space in New York; in 1998, "Il posto dove vivo" at the Juliet in Trieste, and the Studio d'Arte Contemporanea Pino Casagrande in Rome; and in 1999, at the Galleria Le Case d'Arte in Milan, and the Galleria Alberto Peola in Turin.

Marco Calò

Born in Lecce in 1971, he now lives and works in Florence. In 1997, he finished a three-year course in photography at the Fondazione Studio Marangoni in Florence where he took part in workshops with Philip Lorca di Corcia, Mimmo Jodice, Antonio Biasiucci and Anna Fox. He took his degree in sociology with a specialization in communications and mass media at the University "La Sapienza" of Rome with a thesis on visual sociology. He is one of the eight Italian photographers who won the "Napolifotocittà 1997", a prize that resulted *in situ* work in the periphery of Naples which is documented in the exhibition and catalogue *I dintorni dello sguardo*. In 1998, he won the Premio Nazionale Federchimica with his reportage *Supercalifragilisticespiralidoso*. He has taken part in numerous exhibitions with his most important work, *Audience*: at the Galleria Luigi Franco Arte Contemporanea in Turin, the Galerie Municipale du Chateau d'Eau in

Toulouse, the Museum of Photography and Visual Arts in Rome, and the Galleria Giò Marconi in Milan. In 1998, he began *Fuori di casa*, a reportage on the container camps in Umbria. His photographs are conserved at the MIFAV in Rome, the Galleria Civica in Modena, the Museum of the Basilica of Sant'Ambrogio in Milan, and published in many catalogues: *Periscopio 98, Eye-contact, Photographie italienne contemporaine.*

Vincenzo Castella
Born in Naples in 1952, he now lives in Milan. He started his photographic activity in 1975, producing *"Geografia privata"* (colour photographs of domestic interiors) between 1975 and 1982. In 1976, 1978 and 1980, he was in the United States where he realized the project (photographs and 16mm film) *Hammie Nixon's people* (the African Americans, their lives, and the architecture of the Southern cities). Since 1980 he has been photographing the changing landscape, architecture, industrial architecture, and urban contamination. In 1991, he published "Zone". Since 1997 he has been working on the project "Città nomadi" (contemporary Western cities). Some of his one-man shows include: "Le Case d'Arte of Pasquale Leccese", Milan 1995; "Jam" (with Walter Dahn and Philip Pocock), Centro d'Arte Contemporanea, Bellinzona 1996;

"Ausblick" (with Andreas Gursky, Peter Fischli, David Weiss and Louise Lawler), at the Centro d'Arte Contemporanea, Cologne 1997; "Marghera-Bagnoli", "Le Case d'Arte di Pasquale Leccese", Milan 1997. Some of his group shows: "Venezia-Marghera", XLVII Biennale di Venice 1997; "Paesaggi Italiani", Galleria degli Uffizi, Sala delle Reali Poste, Florence 1998; "Pagine di fotografia italiana 1900-1998", Fondazione Galleria Gottardo, Lugano 1998; "Between Past and Present", One Allen Center – Fotofest, Houston 1998; VIII Fotobienal, Museo d'Arte, Vigo 1998.

Alessandro Cimmino
Born in Naples on 15 January 1969, he took his degree in architecture in 1998. His group shows include: in 1996 "Il verde e la città" in Naples; in 1997, "I non luoghi" in Bari; in 1997, "Napolifotocittà" in Naples; in 1998 "Napolifotocittà" at Savignano sul Rubicone (Rimini), "Napolifotocittà" in Genoa; in 1999, "db-architekturbild" "Architettura e contesto ambientale", in Bonn, Nuremberg and Weimar.

Pippo Ciorra
Born in Formia in 1955, he took his degree in architecture at the University "La Sapienza" of Rome in 1982. In 1991, he earned a Doctorate in Composition at the IUAV of Venice with a dissertation entitled *Il*

"museo-città". Musei e architetture urbane nella città contemporanea. He has been teaching since 1982 at the universities of Rome and Venice as well as the North American universities of Ohio State University and Cornell University. Since 1995 he has been teaching Design at the School of Architecture of Ascoli Piceno. He has been a contributor since 1981 to the cultural pages and sections of "Il Manifesto" as well as to Italian and foreign architectural reviews. Since 1996 he has been on the editorial committee of "Casabella". He is the author of *Ludovico Quaroni 1911-1987* (1989), *Botta, Eisenman, Gregotti, Hollein: Musei* (1991), and *Peter Eisenman* (1993). He edited the monograph on Richard Meier (1993). He published for Birkauser *Antonio Citterio & Terry Dwan* in 1995, and *Young Italian Architects*, with Mario Campi, in 1998. Included among his works and projects: the arrangement of some of the archeological work sites on the ancient Via Flaminia, the small Ecomusée of the Casamance in Senegal, the Nuovo Sacher Cinema in Rome, the interior decoration and entrance to the Corderie dell'Arsenale for the 1991 Biennale Architettura, the Q3 quarter of Ancona, the ex-Eden building in Senigallia, Among the competitions he has participated in were the new IUAV building in Venice (commended), a

Museum of Contemporary Art in Turin (third prize), and the new Centre for Contemporary Art in Rome (selected for the second stage). His works have been published in various reviews and exhibited in group shows in Italy and abroad. He participated the in Biennale Architettura of 1982 and 1991, and in the Triennale of 1995.

Paola De Pietri
She was born in 1960. Her one-woman shows: in 1994, "Linea di confine", ex-Palazzo Civico di Rubiera, Rubiera; "Nel Millenovecentonovantatre" at the Casa Spallanzani, Scandiano; in 1996, Galleria Raffaella Cortese, Milan; in 1997, at the ex-convent of Santa Maria in Gonzaga, Gonzaga; in 1998, at the Sala dei Giardini, Biblioteca Panizzi, Reggio Emilia; at the Galleria Raffaella Cortese, Milan; at the Alberto Peola Arte Contemporanea, Turin. Some of her group shows include: in 1997, "La scuola emiliana di fotografia", Palazzina dei Giardini, Galleria Civica di Modena; "Periscopio 1997", Centro Civico di Noverasco; "Romantica", VII Biennale internazionale di fotografia, Palazzo Bricherasio, Turin; "Corto Circuito", Northern Photographic Center, Oulu; "On board" Contemporary Photography.

Paola Di Bello
Born in Naples in 1961, she currently lives and

works in Milan. Her principal one-woman shows: in 1995, "Mi manifesto" at the Galerie Kinter in Stuttgart; in 1999, "Concrete Island" at the Galleria Luciano Inga-Pin in Milan. Principal group shows: in 1998, "Pollution" at the Galleria Gianferrari in Milan; "Subway. Arte fumetto, letteratura e teatro negli spazi della metropolitana, del passante e delle stazioni ferroviarie di Milano" at the Galleria Gottardo in Lugano, "Pagine di fotografia italiana 1900-1998" at the Galleria Gottardo in Lugano, "Le festival off des Rencontres d'Arles" at the Voies Off in Arles (special jury prize), "Nuovo paesaggio italiano" in Milan, "Periscopio" in Milan, "Money Nation" at the Shedahalle in Zurich; in 1999, "Signs of Life" at the Melbourne International Biennial, Italian Pavilion.

Francesco Jodice
Francesco Jodice was born in Naples in 1967; he lives and works between Milan and Naples. He began to photograph in 1993 and since then has used photography as an instrument of artistic research. Prior to photography he worked as a comic strip artist, heavy metal drummer, and "carabiniere". In 1996, he took his degree at the School of Architecture of Naples with a thesis entitled *I luoghi entropici. La fotografia come progetto del territorio*. In 1997, he designed and curated

"Fotocittà", an international show of exhibitions, conferences and publications dealing with the relationship between the culture of the image and the culture of the territory. Among the participants: Catherine David, Lewis Baltz, Stefano Boeri, Bill Mitchell, Rem Koolhaas, Wim Wenders, Daniele Del Giudice, Jean-François Chevrier. He works professionally as a photographer of architecture and territory for "Domus", "Interni", "L'Architettura", "Casabella", "Abitare", "Urbanistica", "Amica", and the Sunday section of "Il Sole 24 Ore". He is a free-lance collaborator of the Grazia Neri agency. He has done photographic campaigns of documentation for companies and administrations, among which, Enel, Ansaldo, the City of Milan, the Naples Port of Authority. He has given lectures and seminars on the perception and the representation of the new social landscapes at the universities of Naples, Milan, Genoa, Aversa, Pescara, Salzburg, Bergamo, and Amsterdam. In 1998, he participated in the drawing up of projects for the transformation of the port of Naples. He is interested in and writes about the relationships between contemporary art, photography, comics, cinema and architecture. He has curated exhibitions and edited publications regarding the latest research in the field of Italian photography. His

own artistic research explores the relationships between the new social behaviors and the modifications of the urban landscape. He has worked for the Triennale of Milan as curator of the photography section. He participated as theorist and photographer in "Tokyo Blanks", a project that examined the modifications in the social and urban fabric of Tokyo by means of its empty spaces, a course and exhibition for the BIA (Berlage Institut Amsterdam). He writes about contemporary photography and video culture for "Tema Celeste". Since 1998, he has been carrying out research using photography to shadow people (Secret Traces) in New York, Paris, Tokyo, Milan, and Rotterdam, investigating the intimate reasons for the changes in itinerary in the daily life of any individual.

Ricci & Spaini
Mosè Ricci, born in Florence in 1956, is Associate Professor of Urban Planning at the School of Architecture in Pescara. He was a Fulbright scholar at the Graduate School of Design of Harvard University, and Visiting Professor at the School of Environmental Design of the University of Waterloo in Toronto. Filippo Spaini, born in Rome in 1955, won a Fulbright Scholarship in 1982 and took a Master of Architecture at Rice University in Houston in 1984. He has been a

member of juries at Syracuse University in Florence, Georgia Tech in Atlanta and Paris, Ohio State in Rome, and Texas A & M at Figline Valdarno. The work of the studio Ricci & Spaini has been published in national and international reviews ("Casabella", "Abitare", "Architectural Record"), and was chosen for the Italian section of the VI Biennale of Architecture in Venice. Collaborating with the studio are: Maristella Abate, Peter Chevalier, Carla Ghezzi, Mario Masci, Antonella Morille, Elisabetta Piccione, Alberto Raimondi, Nunzio Rendinella, Paolo Sabatini, Monica Vittucci.

Renato Rizzi
He was born in 1951, and took his degree in Venice in 1977. In 1984, he won the design competition for a park and sports area in Trento. The work is currently under construction and will be finished in 2001. From 1984 to 1991 he worked with Peter Eisenman in New York. In 1992, he founded the Laboratorio Urbano di Progettazione in Trento. In 1992 he also won the "Premio Nazionale In/Arch". In 1996, he participated in the VI Biennale di Architecture in Venice. He has published: *La fine del Classico*, 1987; *Galleria Museo Depero*, 1991; *Mistico Nulla*, 1996; *Le forme della Necessità*, 1996. He is currently a researcher at the Istituto Universitario di Architettura in Venice IUAV.

Zardini & Meyer
Mirko Zardini, born in 1955 in Verona, took his degree in architecture at the Istituto Universitario di Architettura in Venice. He was an editor for the magazine "Casabella" from 1983 to 1988, and for "Lotus International" from 1988 to 1999. Since 1990 he has been an associate of Lukas Meyer in Lugano and Milan. He has been Visiting Professor in several Italian and foreign universities (Genoa, Venice, Ferrara, Syracuse University, SCI ARC, University of Miami, Politecnico Federale of Zurich, Politecnico Federale of Lausanne, Graduate School of Design of Harvard University). His most recent publication is *Paesaggi ibridi* (Skira, 1996).
Lucas Meyer, born in Florence in 1958, took his degree in architecture at the Politecnico Federale of Zurich. After working with Giorgio Grassi, he became assistant to professor Mario Campi at the Politecnico Federale of Zurich from 1988 to 1995. Since 1997 he has been assistant at the Accademia di Architettura of Mendrisio. He is a member of the Central Committee of the Society of Swiss Painters, Sculptors and Architects.

Cino Zucchi
He was born in 1955, and took his Bachelor of Science degree at M.I.T. in 1978 and a degree in architecture in Milan in 1979. Since 1998 he has been professor of Urban Design and Composition at the Polytechnic in Milan. He has taught in many international seminars and has been Visiting Professor at Syracuse University. He has participated in the organization and design of the XV, XVI, XVIII and XIX Triennale in Milan, and has exhibited at the XIX Biennale in Venice. His interest in urban design is evident from his participation in competitions and consultations by invitation. Among his awards: first prize at European 3 – Piazza Sofia in Turin, "Quale sala per il cinema?", ex-Junghans area in Venice, "Una piazza per Cerea", Porta Serrata in Ravenna. He published *L'architettura dei cortili milanesi 1535-1706* (1989), Asnago and Vender; *L'astrazione quotidiana* (1999), and edited the volume *Bau-Kunst-Bau* (1994). He lives and works in Milan.